LEONARDO THE SCIENTIST

CARLO ZAMMATTIO ENGINEER, TRIESTE

AUGUSTO MARINONI UNIVERSITÀ CATTOLICA OF MILAN

ANNA MARIA BRIZIO università statale of milan

LEONARDO THE SCIENTIST

McGRAW-HILL BOOK COMPANY

New York St. Louis San Francisco

A McGraw-Hill Co-Publication

Copyright (C) 1980 by McGraw-Hill Book Company (UK) Limited, Maidenhead, England. First published 1974. Adaptation 1980. All rights reserved. No part of this publication may be reproduced, stored in a retrieval system, or transmitted in any form or by any means, electronic, mechanical, photocopying, recording, or otherwise, without the prior written permission of the publisher.

Library of Congress Cataloging in Publication Data. Main entry under title: Leonardo the scientist. Essays originally published in The Unknown Leonardo, edited by Ladislao Reti, with additional illustrations. Includes index. CONTENTS: Zammattio, C.: Mechanics of water and stone. – Marinoni, A.: The writer. – Brizio, A. M.: The words of Leonardo.

- 1. Leonardo da Vinci, 1452-1519.
- 2. Scientists-Italy-Biography.
- I. Brizio, Anna Maria.
- II. Marinoni, Augusto.
- III. Zammattio, Carlo.
- IV. Reti, Ladislao. Unknown Leonardo.
- V. Title.

Q143.L5L46 509'.2'4 80-10622

ISBN 0-07-072723-6

Printed in Czechoslovakia

PERUSE ME, O READER, • IF YOU FIND DELIGHT IN MY WORK, SINCE THIS PROFESSION VERY SELDOM RETURNS TO THIS WORLD, AND THE PERSEVERANCE TO PURSUE IT AND TO INVENT SUCH THINGS ANEW IS FOUND IN FEW PEOPLE. AND COME MEN, TO SEE THE WONDERS WHICH MAY BE DISCOVERED IN NATURE BY SUCH STUDIES MADRID I 6r

CONTENTS

INTRODUCTION

MECHANICS OF WATER AND STONE

BY CARLO ZAMMATTIO

Leonardo's studies of hydraulics and the resistance of structural materials and their application in his design for monumental projects of his day.

LEONARDO'S WRITINGS

BY AUGUSTO MARINONI

The contents, style, and impact of Leonardo's notebooks, which point the way to the emergence of a new science born of the union of mathematics and experimental activity, based on the appeal to experience, "without which there is no certainty."

THE WORDS OF LEONARDO

BY ANNA MARIA BRIZIO

Leonardo's thoughts on a wide range of subjects. Sometimes based on experiment and meticulous observation, sometimes on inspired guesses and insights, these texts show us a whole world through Leonardo's eyes, expressed in his own words.

APPENDICES THE BICYCLE 154 BY AUGUSTO MARINONI LEONARDO'S LIFE: A CHRONOLOGY 168 FOOTNOTES 184 LIST OF ILLUSTRATIONS 187 INDEX 189

6 10

68

124

"Leonardo's mind, by virtue of its myriad interrelated activities, becomes a symmetrical object, a system complete unto itself.... the despair of modern man, who remains the prisoner of specialization."

Paul Valéry

INTRODUCTION

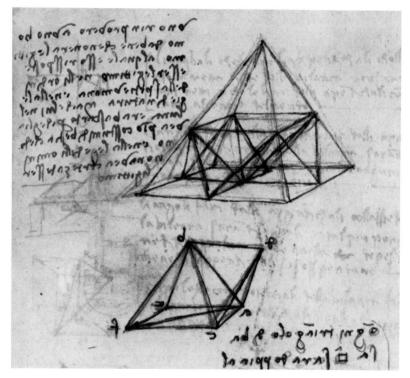

Leonardo, a man of science as well as an artist, saw no contradiction between these two realms. In his geometrical studies, as in his mastery of linear perspective, art and science seem to be united. This sketch, from Codex Madrid II, folio 65 recto, demonstrates that "Every pyramid of square base will be the double of one of triangular base?"

Les marina diversion de la constante Les marinans de constante Les marinans de constante les marinans de constante d'una diversion de constante d'una de constante

Augurister bour will a build will a sured a sure and will will will a sure and a sure and a sure a s

manu sile port

Metter & Gundtherman an elon serman formation & pravio centre formation & mister diamontes on a mister diamont "All sciences are vain and full of errors that are not born of experience, mother of all certainty, and that are not tested by experience . . ."

VECHANICS OF VATER AND STONE

CARLO ZAMMATTIO

Leonardo's notebooks reveal a man whose curiosity seemed boundless, who could explore painting techniques as well as hydraulic engineering, comparative anatomy and musical instruments, massive sculpture and machines of all kinds; a man who was at once an artist, an inventor, a scientist – and who saw no contradiction between these diverse realms.

In his unceasing quest for truth, Leonardo explored every branch of the sciences known to his age and proved in many respects to be far ahead of his time in his precise observations, his striving for sound methodology and measurement, and the value he placed on empirical proof. "No human investigation," he wrote, "can be called true science without going through mathematical tests...the sciences which begin and end in the mind cannot be considered to contain truth, because such discourses lack experience, without which nothing reveals itself with certainty."

This book and its two companion volumes, *Leonardo the Artist* and *Leonardo the Inventor*, comprise chapters taken from the voluminous work, *The Unknown Leonardo*, which was based on the discovery in 1965 in Madrid of two of Leonardo's notebooks. These notebooks, whose existence had been questioned since his death, were exhibited following their discovery and published shortly thereafter by McGraw-Hill and Taurus Ediciones under special authorization of the Spanish Ministry of Education. Commonly known today as Madrid I and II, the notebooks shed new light on Leonardo's many interests and explorations. In *Leonardo the Scientist* several Vincian scholars subject his scientific thought to careful scrutiny.

The newly discovered Madrid Codices contain Leonardo's daring plans to alter the course of the Arno in order to create a navigable canal linking Florence to the sea. In his study of water flow in connection with this scheme, Leonardo worked out, as Carlo Zammattio shows here, what was to become the basic theorem of hydrodynamics. In Codex Madrid I, moreover, Leonardo noted that energy was a function of position and motion, thus differentiating potential from kinetic energy. Leonardo combined his capacities as engineer and artist, synthesizing visual and structural elements in his studies of stress distribution in arch construction.

Augusto Marinoni's chapter on Leonardo's writings is far wider ranging in scope, since it attempts to trace the development of his thought throughout his career. Here we see how Leonardo kept his notebooks, sometimes developing a coherent treatise, sometimes jotting notes haphazardly on the most disparate subjects. In his writings Leonardo points the way to the emergence of a new science born of the union of mathematics and experimental activity, based on the appeal to experience, which he believed so essential. A final chapter, introduced and edited by Anna Maria Brizio, cites Leonardo's own words on a wide range of subjects, including his own methods, perspective, light, optics, hydraulics, air motion, gravity, motion, birds in flight, condensation, precipitation, anatomy. Sometimes based on experiment and meticulous observation, sometimes on inspired guesses, insights, and speculation, these texts show us a whole world through Leonardo's own eyes.

"There is no antagonism in Leonardo's mind," as Anna Maria Brizio points out, "between art and science." The underlying unity in Leonardo's diverse endeavors is the respect for nature, the desire to learn her secrets and her laws. Painting he defined as a "science" and the "true daughter of nature"; and he saw the artist as locked in a struggle with nature – but it was a struggle to emulate, rather than oppose her. Another key to the harmony of art and science, in Leonardo's world view, is found in the concept of perspective, which "crowns the natural sciences."

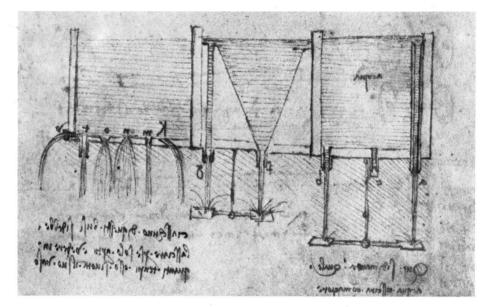

In the diagram above, from Codex Madrid I, folio 152 recto, Leonardo experiments with the force of water flow. He has designed various shaped holes for the tanks and he asks, "Which water will issue with greater impetus, that which issues from pipe a or that which issues from pipe b, or c? Each of these holes must be left open separately." Leonardo's notebooks touch upon an immense range of topics, and he often sketches in a hurried manner to keep up with his inquiring thoughts. On other pages, however, like that taken from Codex Atlanticus, folio 168 recto-a, at right, beautiful patterns result from descriptive drawings. Here, a perplexing exercise in geometry.

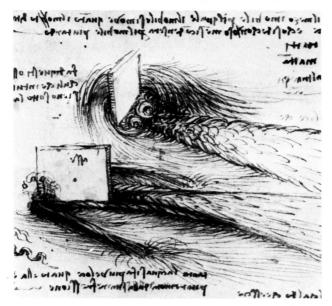

The movement and the behavior of liquid particles impelled by a motion different from that of the mass in which they are immersed, and the formation of fluid threads, for a long time formed one of the main subjects of the hydraulic case histories studied by Leonardo.

The practice of flooding the land to obtain grain harvests throughout the year was certainly very old, as confirmed by Vergil. In the areas below the foothills of the Alps the flood waters could only be obtained from the large Alpine rivers, although in these areas their beds were already meandering through the alluvial strata of the Po valley. Even during the barbarian domination of the valley the irrigation network was not neglected, as proved by present-day nomenclature which can be traced back to their languages. But these works, although based on a tradition thousands of years old, were not the result of theoretical research. Research in hydrodynamics was not even started by the Greeks or their Hellenistic followers: except for the discovery of the simplest laws of hydrostatics (such as the law of communicating vases or the buoyancy law, due to the genial intuition of Archimedes), the ancient world limited itself to conceiving wonderful and sometimes spectacular water contrivances, like those which have survived in writings attributed to Heron of Alexandria. Hydrodynamics remained a mystery for the Greeks probably because the nature of fluids, bodies that are unidentifiable by a well-defined shape, makes it particularly difficult to formulate their problems. The

conceptual difficulty of formulating quantitative relationships for a continuum may have contributed to this neglect. Greek mathematical science was entirely based on visualizable geometric quantities, such as straight or curved lines, which were inherently representable by magnitudes, that is, by numbers; and relations between numbers were only conceived by the Greeks as ratios. The concept of magnitudes varying continuously was never considered by the Greeks; hence, for example, their difficulties in formulating laws of the free fall of bodies. The only

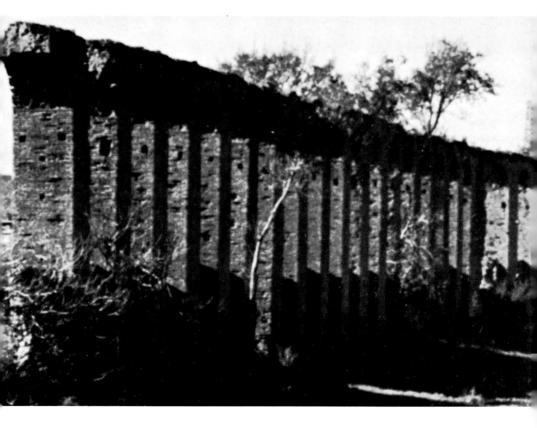

phenomenon of continuum mechanics mathematically solved in classical antiquity was that of the vibrating string, which can be quantified and expressed by the numbers of the harmonic progression.

The works of practical hydraulics in the Po valley, the irrigation network extending from the western Alps to the Adriatic, and, above all, the canals for inland navigation which at Leonardo's time were already two centuries old must have opened to his eyes new and unexpected horizons. They must have aroused in him a curiosity as to the very nature of the liquid element and the mechanical laws governing its behavior. Herein lie the absolute originality of the man in comparison with his predecessors and the mark of the new times, which aspired to understand intuitively a mechanical phenomenon before trying to find its scientific explanation.

As a student of bydraulics and structures Leonardo was heir to a rich legacy of practical experience. The Romans had built in Italy, France, and Spain vast networks of aqueducts to carry water to the cities of their empire. These ruins rise above the Campania plains near the Via Appia leading to Rome. The oldest of the aqueducts, the Acqua Claudia, built in 312 B.C., is still in service. It was restored, along with the remains of the Acqua Marcia, by Pope Sixtus V, and even today supplies Rome with 5 million gallons of water daily.

We are thus led to identify two separate fields in Leonardo's studies in hydraulics: his research on hydrostatics and hydrodynamics, on the one hand, and his projects for large hydraulic works, on the other. We may safely assume that his speculations in the two fields proceeded simultaneously, one stimulated by the other, since a realization of the factual validity of empirical rules always prodded Leonardo into trying to understand them scientifically. To understand: this was the main goal of the man and of the new times he announces. To understand through rational thinking, since, in all physical phenomena, "if you understand the reason, you don't need experiments." Only when it is difficult to understand a priori the single theoretical cause of a variety of phenomena are experiments needed to find among many possible hypotheses the one that is capable of explaining them all. This philosophy is particularly essential in hydraulics because of the changing shape of fluids. While the mechanics of rigid bodies had been studied with notable success in ancient and medieval times, before Leonardo nobody had even tried a similar theoretical approach in the field of fluid dynamics, although hydraulic works, of great significance even to us, had been realized in the past – among them the aqueducts, from that of Eupalinos in the seventh century B.C. to those built by the Romans in Italy, France, and Spain in the first and second centuries A.D.

It is typical of Leonardo's mind to have tackled problems in these unexplored theoretical fields. He may also have been motivated to study hydraulics by the custom of the duchy of Milan to sell water for irrigation to the lands adjoining the network of canals: the corresponding dues were in proportion to the water drawn. The big canals, built in northern Italy between the 12th and 15th centuries, had not only navigational purposes but also the specific aim of furnishing water for the irrigation of vast areas at the foot of the Alps. These regions, situated above the level of the surface wells, next to the morainic hills of the Alpine glaciers, are arid because of the nature of the terrain. The land continues to be arid as it slopes to the plains of Lombardy and Piedmont their heathlike appearance. The practice of water measurement was unknown in Tuscany, on the other hand, where the water of the local grain and textile mills, and this only in limited areas.

In the Po valley, where the rivers never go completely dry, the relatively minor changes in flow allowed the regular distribution of water in the areas crossed by the canals. This water was measured in "ounces," a unit related to the area of the outflow opening in the side of the canal. Leonardo's curiosity was immediately aroused by the following question: is this a correct way of measuring water flow? As the sale of water by the "ounce" was a substantial source of ducal income and as litigation about water measurements was common, it is not unlikely that Leonardo heard of it and may even have been consulted on this matter. The problem must have certainly fascinated him because it involved the whole question of the behavior of fluids in motion.

The sight of the great canals of Lombardy excited his imagination at the thought of what could be achieved in his own Arno valley, to the great financial benefit of Florence, but it also suggested to Leonardo the importance of theoretical studies on the flow of water. The Codex Atlanticus contains his first schemes and ideas on how to regulate and divert the flow of the Arno.¹ This was a grandiose project which went far beyond what had been done till then even by the enterprising people of the Po valley. Immediately upon leaving Florence, the river was to be diverted towards the plains of Prato and Pistoia (these towns, in return for the water and the power supplied to their wool industries, would provide "labor for the works"), crossing on canal bridges the Apennine torrents. The river would have provided water for the irrigation of those plains, which are dry to this day. The Arno was then to go under the mountain pass of Serravalle in a trench or a tunnel (the choice of solution is not clear - Leonardo merely says "cut across Serravalle") and via the marshes of Fucecchio, now drained, was to flow into the "Sesto" marshes, which correspond to the present zone of Coltano, south of Bocca d'Arno, thus avoiding Pisa, the hated enemy of Florence. Although Leonardo's thoughts are never even vaguely chauvinistic, it is not unlikely that a historical background of town fights may have influenced his decision not to end the course of the Arno in the harbor of Pisa, which in any case, although well equipped, was already in full decadence because silted up by the river.

Drawn up along these lines, the project would certainly have found support throughout the Florentine zone of influence. This support was all the more necessary because in order to regulate the flow of the Arno, particularly during the summer months, Leonardo had foreseen two gigantic operations: the transformation of the huge valley of the Chiana, then marshy, into a large artificial lake to act as a retention basin; and the emission into this basin, through a tunnel under the hills between Mugnano and San Savino, of the waters of the Tiber, tapped below Perugia, south of Lake Trasimeno. Lake Trasimeno, moreover, was to become part of the large new artificial lake, whose level was to be stabilized by gates placed below Arezzo, thus regulating the Tiber waters destined to integrate the Arno's flow (pp. 18–21).

The details of the individual works for this project, scattered particularly through the pages of the Codex Atlanticus, show the evident derivation of Leonardo's plans from the works of the Po valley, as is to be expected, since these incorporated the results of centuries of practical experience. It is sufficient to remember here how two years after the Battle of Legnano, which gave to the towns of northern Italy a large amount of independence from the German empire, work

Leonardo's scientific drawings of water in motion endure today as works of art. Here he sees a shaft of water pouring from a square hole into a pool forming a chrysanthemum-like image of bubbles and swirling lines. This drawing probably was made about 1507 in connection with a hydraulic project in Milan.

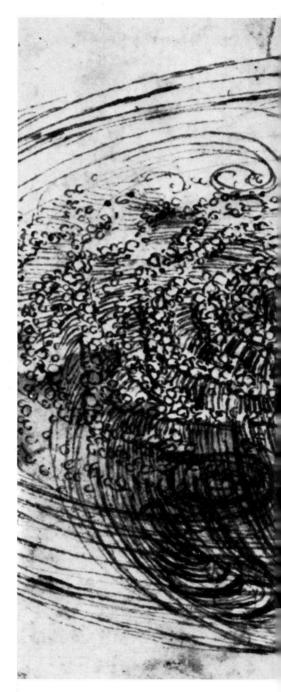

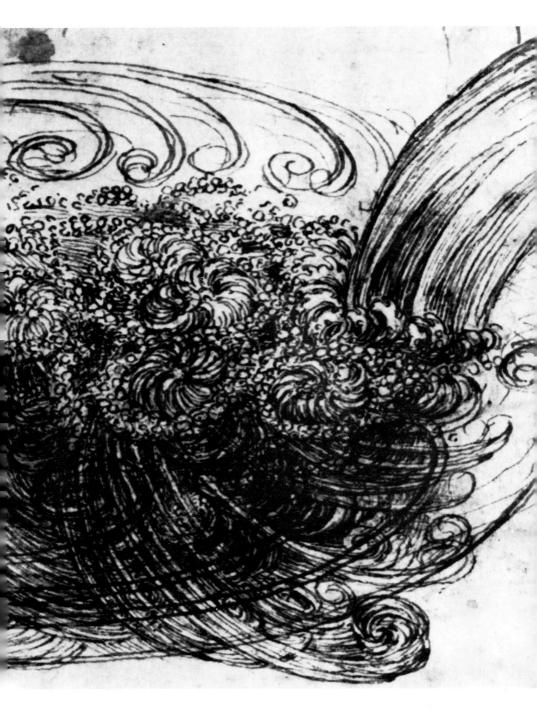

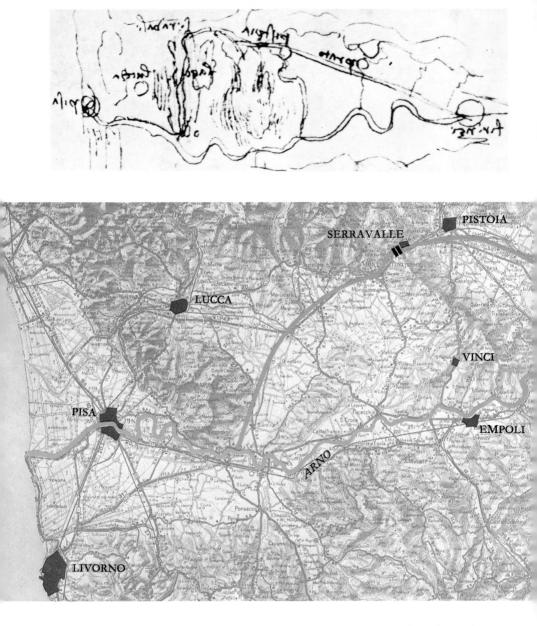

Leonardo studied the possibility of building a waterway from Florence to the sea. The idea of diverting a long section of the Arno River into a man-made canal, to irrigate arid plains and make possible large-scale navigation from Florence, was more than 100 years old. But Leonardo made the idea his own and evolved the complex series of engineering challenges charted here. Leonardo's sketch above traces the proposed canal from Florence to east of Pisa where it would rejoin the Arno River. was started on the canal later to be called the Naviglio Grande. The waters for this canal were tapped from the Ticino River (hence its first name, Ticinello) below Sesto Calende, and remnants of its excavation and construction of dams may still be seen today at the river bank. These waters at first were channeled only up to Abbiate Grasso, but under the *podesteria* ("mayoralty") of Martino della Torre in 1256 the canal was prolonged to Milan, where its waters entered the exterior moats of the city. The canal banks were equipped with wharves for barges, and in 1271 under Beno de' Gozzadini a large trench – Redifossi – was built which

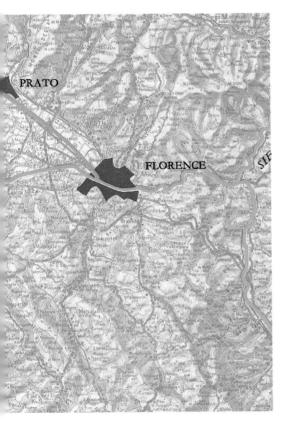

One of his boldest innovations was his intention to route the canal under the mountain pass at Serravalle, near Pistoia. His sketch (right) demonstrates how excavations could be carried out accurately.

The color map at left reveals the grand scope of Leonardo's Arno projects. The main section of the waterway begins at Florence, where the Arno, winding west to Pisa and the sea, becomes impossible to navigate. His canal (in green) cuts northwest past Prato and Pistoia, then turns southwest through a tunnel or trench at Serravalle and again meets the Arno east of Pisa.

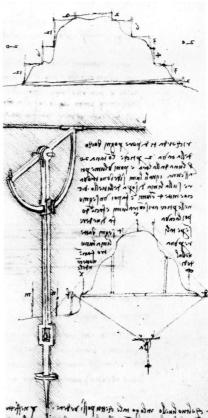

collected and discharged the waters of the canal and of the small torrents which passed through the city. This extraordinary work allowed the merchandise of the Milan market to travel by water to the foot of the Alps, a journey it had made by road since neolithic times by following the upper part of the Ticino valley up to the passes of San Bernardino, Lucomagno, and Gotthard, which had recently been opened to traffic. At the same time other waterways were being built at the initiative of other towns: one between the river Adda and the southern area around Lodi: another between the northern area around Novara and the middle valley of the Ticino, on its right bank; and a third between the rivers Dora and Sesia, which ran at the foot of Ivrea (the "Navilio d'Invrea," notes Leonardo). These canals, wide enough to allow the simultaneous passage of two large barges, had required the solution of many complex problems in construction and hydraulics, because their waters were drawn from rivers which were periodically flooded by the sudden melting of the Alpine snows in the spring and by the fall rains. To obtain such results a good knowledge of water flow, based at least on sound experience, if not on theoretical studies, was necessary; and this is the ancient empirical legacy Leonardo found in the Po valley.

Leonardo's sketch at left from Madrid I 114v shows a bellows pumping air into a vessel of water. It is one of many sketches aimed at calculating how the weight of a fluid is transmitted through that fluid.

Leonardo realized that to understand the great works built along the rivers of the Po valley, one had to grasp the laws of fluid flow. To be able to think about the realization of the great projects he dreamed of for his own Tuscany, he had to establish the mechanical behavior of fluids.

It is here that his individuality and novelty contrasts with the thought of the preceding centuries: his scientific curiosity needed to know the reasons behind the empirical rules and could not be contented with their passive acceptance. Leonardo was the first man to realize that any physical phenomenon must be reduced to its mechanical essentials, and to him hydraulics was a totally unknown field which had to be thus explored. He was particularly attracted to it by the fact

on A

8:00

(wA

m):A

MI

1:400

, with

'00

1

4 SM

· AN'T

NN

1403

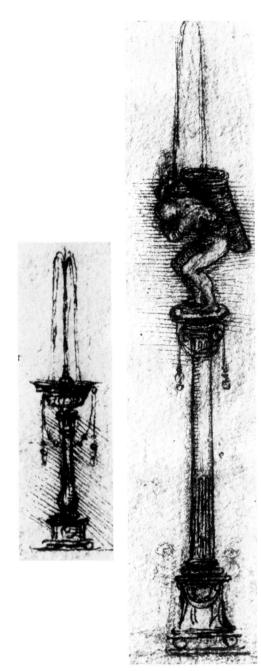

One of the few early researchers in hydraulics was the Greek Heron of Alexandria, who lived in the first century before Christ. He devised fountains which Leonardo copied (pictures at left). In the center drawing, water squirts from a pipe held by the nude figure into the basket on his back. In the sketch at far left, water rises to the top by means of a siphon, which Heron invented.

Above: On folio 150 recto, he calculates the force that water exerts upon the bottom of a vessel.

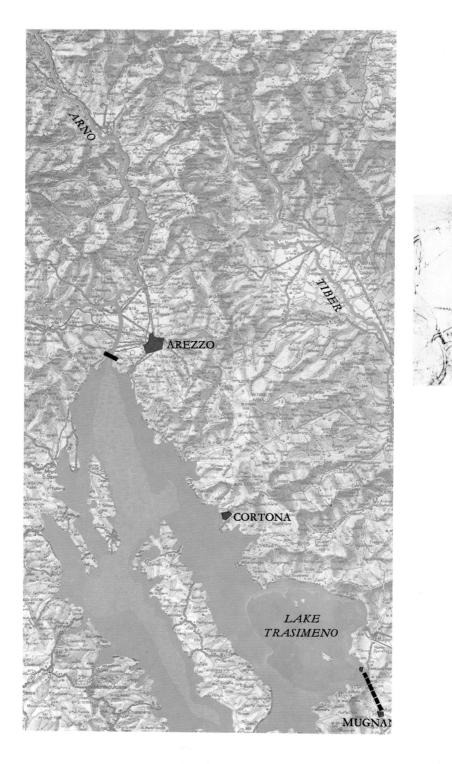

To maintain the Arno and its canal at a navigable level, Leonardo suggested creating a large artificial lake (in green) by flooding the marshes of the Val di Chiana (in blue), near Arezzo, and linking them with Lake Trasimeno. His sketch below, Windsor Collection No. 12682 recto, is an imaginary perspective of the upper part of the Val di Chiana, where gates with a regulating device were to be placed. The map also shows Arezzo and below it the junction of the canal and the Arno. To get water for the reservoir, he suggested tapping the Tiber River near Perugia, southeast of Lake Trasimeno, by digging a tunnel (drawings at bottom).

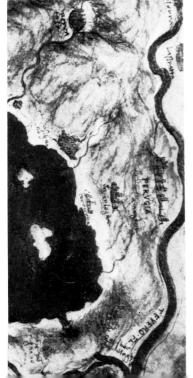

The detail from Leonardo's map at left clearly shows the tunnel linking the Tiber with Lake Trasimeno.

The map below is a detail from Leonardo's map of Northern Italy, focusing chiefly on the watersheds of the Arno River. It shows the west coast and Pisa at lower left and includes the entire course of the Arno.

that a fluid, in adjusting itself continually to the shape of its boundary, realizes ideally continuity of mass motion, a concept studied today in continuum mechanics. What strikes most the careful observer of such fluid motions is that under certain conditions they appear to be stationary, i.e., that while the fluid mass flows, at any point along the flow path all the (invisible) fluid particles behave identically. The surfaces which define the shape of the fluid mass, such as the banks of a river or a canal, are subjected instead to permanent changes due to the local accelerations (impacts and suctions) of the water, which erode and tear the material of these surfaces. Leonardo realized that to understand the great works built along the rivers of the Po valley, one had to grasp the laws of fluid flow. To be able to think about the realization of the great projects he dreamed of for his own Tuscany, one had to establish first the mechanical behavior of fluids.

WULLAN BUCH the me class AN ACTIVA AL Av. p. mimul A. Elle Gam p.v.L.Der AN (A) PINST of a faction m. to white day HA SUU (ND HILL Billin our de to Mip sero. of הקרה (הנתואה כי A. - MANNON gunne foliers melunto b. na 000 0641 In spratme in Ailm d.A. AND ments onto face regardent come tunin mate liprime notico איומי ואיט באלם שמוזהה כלי מלאו שבוי אוחה א בחברו אי aromi tratan ... when the . where . A charmer despion For Chegan Artino Bottono

This behavior is of a very particular kind. The individual particles of a fluid, although bound by their common volume, seem to behave independently of each other and yet to feel the impulses of the other particles, both near and far. This is not the case for solid bodies, each one of which can be considered as separate and with given finite dimensions. (Because of these characteristics, mechanisms made of wheels, gears, and ropes are easier to study, to understand, and even to invent.)

Under the label "Nature of water" (above), Leonardo shows in Codex Madrid I, folio 125 recto, that water seeks its own level – a demonstration apparently copied from the writings of Heron. In the sketch at far left,

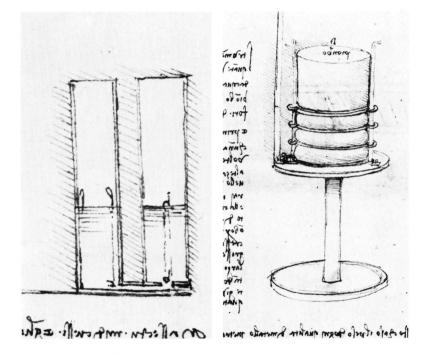

Madrid 1, folio 124 verso, Leonardo correctly figures that under equal pressure water will spout higher out of the narrow vessel. The next sketch, from folio 115 recto, is a demonstration of the tendency of spouting water to reach the same height it had in the container. Next, on folio 150 recto,

Here the question is asked: which of these four waterfalls has more percussion and power in order to turn a wheel: fall a or b, c or d? I have not yet experimented, but it seems to me that they must have the same power, considering that a, even if it descends from a great height, has no other water chasing it, as has d, which bears upon itself the whole height of the thrusting water. Now, if fall d has a great percussion, it has not the weight of fall a. And the same is true for b and c. Consequently, where the force of percussion is lacking, it is compensated by the weight of the waterfall.

(it monthe . Only Banche - anners . charter ACHNA 10 4 . W. WWWW. Dred Now Hisborn & . . . the man note . No la carfair. a. ho b. c hog and wir de wegar . nolo preventione delle delle de lono : f: figurt: porter mpo elero Gonfitero E: fila eganne n. A arts horas alies .. in nous prich all .. igila ofvers come . pr. 4 : ilinger of other for tutte Culties As hand Rola of preprise hore fromten file when the as Surbani Elle none alle d'ele de verdanne v. E Golif: guin . In. b. c. moto de for made la fors An Mon: amproprifer: itp: to fella capun silaer

The field of fluid flow, besides being mechanically different, was entirely new: there was nothing Leonardo could have learned from classical science about either liquid or gases.

Here we come to appreciate the qualities of Leonardo's mind. He started from the drawings of the water contrivances invented by Hellenistic technologists, contained in the work of Heron; by analyzing and co-ordinating the results of this technology, he was able to invent new contrivances, which show him to be the first man in history to have tackled hydraulic theory. (Some pages of Codex Madrid I throw light on devices of Leonardo which were already known to us, but not as clearly, from two folios of the Codex Atlanticus.) How is the weight of water transmitted through water? This is the basic problem of hydrostatics and was also

The motion of fluids had everyday significance in the Po region, where canals were used to generate power. Here, perhaps because of his role as ducal engineer, Leonardo studies the work done by three types of waterfalls. Above, in the case of a small flow from a high fall, he suggests in Codex Madrid I, folio 22 verso, the use of a narrow vertical pipe to concentrate the force of the water as it strikes the vaned wheel.

In the two sketches shown below, from folio 151 verso, he considers the problem of splitting a strong flow from a small fall into four equal flows. Most important is his study in 134 verso (opposite page) of water falling at four different heights from a container. He concludes that the "power," or energy, is the same for each waterfall, a basic theorem of modern hydrodynamics.

apm 9

I've buy with י את אות ייוחויווי י (יכטולט כרילה זויכו אות לוס and alle particles decenfrancing grad modal : e CAMALIONE Dole . 09: 11: ELA ORDENIAL ANIT Time An De (verlav - M. D. Bide: - 26, 4. 1 (valow - who rever & 38 a point of while m. Magnessel in

the first studied by Leonardo on the basis of his reading of Heron. We do not know whether its solution came to him in a flash of intuition or as the result of studying the analogy between the equilibrium of fluid particles and that of transparent spheres (such as glass marbles), but the fact is that he categorically asserts in Codex Madrid I that "every part of the skin feels equally the pressure of the weight."² Of course, the question to be asked is not only qualitative but also quantitative: in what measure does each part of the bag containing the fluid feel the weight acting on it? All the devices used by Leonardo to answer this question in Madrid I³ are derived, relying on the principle that water in communicating containers seeks its own level, from a scheme in the codex⁴ which is very similar to a scheme in Heron, reproduced in the Latin translation of Commandino and the Italian translation of Giorgi.

It must be pointed out that Leonardo, in studying connected containers, takes into account both the liquid and the air in the containers, thus showing that he considers the behavior of these two fluids as equivalent. Here, however, begin Leonardo's difficulties: he failed to notice that the pressure inside a container depends not only on the weight of the liquid but also on the surface on which the weight acts, so that it is the force per unit of area at a given level which is equal to any unit area of the bag in contact with the fluid. When he drew the drawings in Madrid I,⁵ Leonardo believed that the pressure due to the weight would spread to the whole of its "vacuum," that is, over the entire remaining surface of the container (pages 20 and 24). This seems to us the only plausible interpretation in which Leonardo's speculations on this subject are presented in a detailed and precise manner. (What was known about it before Madrid I was quite vague and undetermined.) It probably seemed absurd to him that the sum of the outward fluid pressures could be much greater than the resultant of the entire weight, since to him this was tantamount to saying that power could be generated from nothing. At the time he was not in a position to consider the equilibrium of an element of fluid in contact with the surface of the container and to realize that this element must be equally pressed on all sides if it is not to move away from the container's surface, since this kind of consideration was only developed 300 years later. His error, which seems to have become firmly established in his mind in two successive stages, is understandable. In fact, previously, in a "Definition" in Madrid I under the heading "Nature of Water,"⁶ the pressure in a cylindrical container with an accordion-like expandable bottom, full of water and burdened by an additional weight, is equivalent from the height reached by a jet of water issuing from a pipe connected to the container (p. 24). This height is assumed to vary inversely as the ratio of the "magnitude" (diameter) of the pipe to that of the container and hence

is not referred to its entire bottom surface.

Nevertheless, Leonardo obtained results at least qualitatively correct, so much so that in his drawings of cylindrical containers loaded by the same weight (1,000 pounds), the jet of water spouting out of the smaller-diameter container m is higher than that spouting out of the large-diameter container n. We say that this happens because the loaded surface of the container m is one-tenth of that of the container n and hence the pressure in m is 10 times that in n. Leonardo instead reasoned that since the jet pipes of both containers had the same dimensions, the pipe in n had a diameter equal to one-hundredth of its container's diameter, while the diameter of the pipe in *m* was one-thousandth of its container's diameter, i.e., 10 times smaller. Leonardo noted that the top of the water jet reached the level of the water in the container, as shown by one of his Codex Madrid I sketches (p. 24). Equally correct were his experiments with collapsible-walls containers to determine the specific weights of solids by using different liquids in the container (p. 25). 8 In this case Leonardo saw to it that the weight was cylindrical and of the same diameter as the upper surface of the cylindrical container, so that the pressure in the fluid equaled the weight of a column of unit area of the solid. In this situation, to explain the role of the fluid pressure, Leonardo imagines the cylindrical weight subdivided into many elementary vertical cylinders, under each of which is a liquid vertical cylinder of equal diameter. While for all the other liquid cylinders the pressure due to the weight is balanced by the reaction of the container's bottom, for the elementary cylinder located over the bottom's opening (which has the same diameter as the elementary cylinder) the pressure due to the weight is balanced by the weight of the column of water which rises in an external U-pipe connected to the bottom opening. The water in the pipe rises a multiple of the weight's height which represents the ratio of the specific weight of the solid to that of the liquid. The same device is used by Leonardo for schemes of hydrostatic scales in equilibrium in Codex Madrid Iº and in other contexts in the Codex Atlanticus and the Codex Leicester.¹⁰

While Leonardo was thus trying to establish the laws of hydrostatics, he did not lose sight of the importance of studying fluid motion, since it was common knowledge that when the flow of water is deviated or prevented, a pressure is created which, if devastating at times, may also be put to profitable use. This knowledge was particularly important in the Po region, where the water of the large canals was utilized to generate power and was a rich source of government income. The high cost of the damming and banking works, on one hand, and the value of the concession of hydraulic power, on the other, gave high priority to a

"Quantity of a true ounce of water."

Probably entrusted by the French governor of Lombardy with the job of solving once and for all the problem of water measurement, Leonardo proposed a method for measurement of water by the "ounce." In his sketch here, the quantity of water issuing from the opening is directly proportional to the water head above it. The accompanying text states that "the quantity of water that pours through a given opening in a given time will be the same as that from the given height of the opening," meaning by "height" the vertical distance from the upper surface.

problem, probably submitted to Leonardo by the fiscal authorities, which involved the role of two essential variables: how did the work done by the distributed water depend on its mass and on the height of the waterfall, measured from the distribution orifice to the collecting canal? We can consider in this context three situations studied by Leonardo in some notes of Codex Madrid I: (1) a small flow from a high fall (27, left); (2) a flow from a small fall (about 5 feet high) of such magnitude as to require splitting into four equal flows, each producing the same amount of work (27, right); and (3) the general case of tapping water at various heights from the wall of a container, in which the water level is presumably kept constant (p. 26).

Let us only consider the last case, which is the most interesting because it contains elements of wider scientific scope than the other two.¹¹ Even though the individual jets start to leave the container under different conditions, with initial spouting speeds which increase as the tapping level is lowered, Leonardo concludes that the "power" (*potentia*) is the same for all the spouts, because "where the force of percussion is lacking, it is compensated by the weight of the waterfall." Leonardo's

Leonardo's observations on water measurement and distribution for irrigation purposes found their practical application one year following the study below. The precise execution of this drawing leaves hardly any doubt that it was meant to be shown to the French authorities. Leonardo became convinced that the outlets for irrigation should have a prevalently horizontal development, of small height, so as to reduce the dragging influence of the faster lower strata.

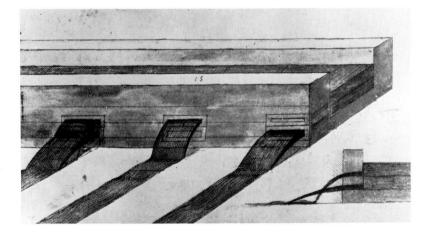

argument, which is written as if he were debating it with himself and were in need of later experimental verification, seems to run as follows: Each water particle, while falling freely, obeys the action of its own weight only; it moves because it has weight. In so doing it acquires an impetus [what we call momentum] which leads to percussion [what we call impact] if it finds an obstacle. A particle at the bottom of the container, however, feels not only its own but also the weight of all the particles above it up to the free level of the water, which weigh down on it. The weight of the particles all the way down to the container's bottom is all that determines the power of a particle at the point where it leaves the container through the bottom orifice. But for a particle initially above the bottom of the container the power upon reaching the level of the bottom consists of two parts: one due to the weight of the column of water initially above it and another due to the momentum deriving from the speed acquired during the fall. As the part due to one cause increases, the part due to the other decreases. At the free upper surface of the water the power due to the superimposed weight vanishes, at the bottom of the container the power due to speed vanishes. Hence at any other level the power remains constant.

Naturally, in his reasoning, Leonardo did not and could not use our precise terminology. In particular, the concept "energy" had to wait more than three and a half centuries before its precise definition allowed it to become a fundamental concept in our understanding of the physical world. Nevertheless, the conclusion reached by Leonardo is of the greatest importance because it constitutes nothing less than the basic theorem of hydrodynamics. In its wording as well as in its substance it is the law announced in 1738 by Daniel Bernoulli (below): all we have to do is to substitute our term "energy" for the word "power" (*potentia*), our "potential energy" for "weight," and our "kinetic energy" – what Leibnitz improperly called "live force" – for "percussion."

The great importance of Leonardo's conclusion, particularly in his time, becomes clearer if we notice that it is not at all self-evident that "where the force of percussion is lacking, it is compensated by the weight." For this assertion to be true, one must assume that at the beginning of its free fall the initial speed of a

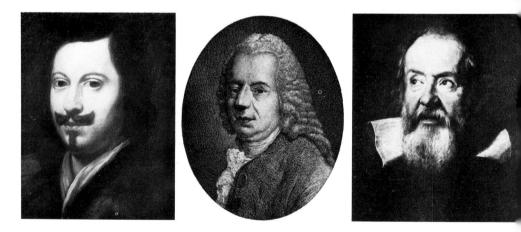

Leonardo's conclusions about the power of falling water were so farseeing that they brought him to the brink of theories formulated by three famous scientists much later. In his consideration on page 26 of waterfalls from four different heights, he correctly saw that the energy of the falls depended upon the relationship between their velocity and the height of the water inside the container. In everything but precise terminology he bad arrived at the basic theorem of hydrodynamics developed in 1738 by Daniel Bernoulli (middle), one of a Swiss family of distinguished mathematicians. Even more astonishing, his conclusion involved an intuitive understanding of the law governing the speed of falling bodies. This law was not deduced until the experiments of the Italian physicist and astronomer Galileo Galilei (above right) were performed and not clearly enunciated until 1642 by his countryman Evangelista Torricelli (left). particular jet is equal to that reached at the same level by the jets tapped higher up, so that, from the level of this particular jet on, the water in all the jets moves under identical conditions. But this implies the validity of the law governing the speed of falling bodies, a law deduced from the experiments of Galileo and clearly enunciated by Torricelli in 1642.

Of course, what has been said so far is only valid while the flow in all the taps is identical. Leonardo does not say so explicitly, but this premise must have been in the back of his mind, because it is obvious that comparisons can only be made between identical quantities of water flowing in identical time intervals. It would be absurd to consider equivalent the "power" of a trickle of water and that of a river. But since Leonardo had already recognized that the flow from an orifice depends on its area and on the exit velocity and since this last increases from top to bottom, to obtain the same amount of flow from all the taps one would have had to vary the orifice cross sections with the depth. Since the orifices in Leonardo's drawing for the water-tapping case have all the same height and since Leonardo only considered rectangular orifices (like those used in his time in Lombardy for the water outlets of the irrigation canals), their widths would have had to vary inversely as the square root of their vertical distances from the free level of the water to be in accordance with Torricelli's law.

At that time the law governing the fall of heavy bodies was not known, and Leonardo seems to have felt a need to prove the correctness of his intuitions about "power" by giving a more specific definition of fluid flow. That he was turning this thought over in his mind seems to be proved by the fact that when, some years later, he proposed a method of measurement for water by the "ounce," he returned in Manuscripts F and I to the same scheme, drawn in the same manner, noting on the side "Quantity of a true ounce of water."¹² (The French governor of Lombardy probably entrusted him with the job of solving once and for all the problem of water measurement during his second stay in Milan.) (pp. 30 and 31)

It is likely that as ducal engineer Leonardo was given charge of the hydraulic sector, one of the most important for the economy of the duchy. In any case, his interest in the hydraulic works of Lombardy was permanent and went even beyond his fantastic plan of making Florence a center of water traffic. But Leonardo's notes consider, besides questions on hydraulic works, problems of water power, and it is doubtful that he would have tried the solutions of problems like those mentioned above had he not been requested to do so. Among the water-power problems we find that of the full utilization of the flow from a large

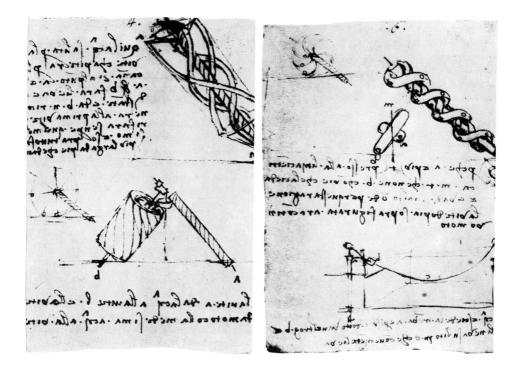

Leonardo must have observed that a liquid in curvilinear motion, led by the wall of a groove or a pipe, exerts a pressure back onto the same wall: he must have inferred that this pressure can furnish torque and.

accordingly, he conceived conical spiral tubes (with rising lever arm) as a substitute for the usual waterwheels, in order to activate snail tube machinery for raising water.

canal, which he subdivides into four channels activating four separate waterwheels, since, for purely mechanical reasons, it was then impossible to absorb the entire power of the canal by means of a single wheel. And here his thought goes to the water mills of the Certosa 4 miles above Pavia (still in existence on the Pavese Canal and with a head of about 15 feet), which might well be identified with a drawing in the Codex Atlanticus.¹³

It is certain that Leonardo had made a name for himself in the field of hydraulics since, after the fall of Il Moro, he was requested by the Venetian senate to work out a plan for the flooding of the lower Isonzo plains below Gorizia (Friuli) in the event of potential incursions on the part of the Turks, at that time the major threat at the eastern frontiers of the Venetian domains. The folios of the Codex Atlanticus contain the outline of part of the report Leonardo gathered at the time of his

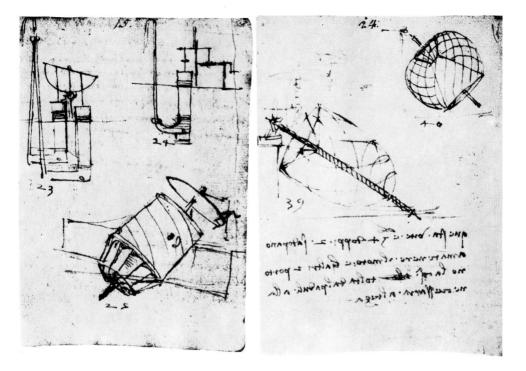

mission to Friuli. In it he suggests an adjustable dam on the Isonzo, mounted on trestles and equipped with gates pivoted along their upper horizontal edge, which would allow the rapid raising of the water level as well as the free flow of sudden floods. Leonardo remembered this device again 15 years later in France when he studied the flood control of the Loire and Cher rivers and, especially, the draining of the Romorantin marshes.

In the field of river-flow regulation Leonardo was helped by his prolonged studies on flow perturbation in canals and rivers, started at the beginning of his stay in Milan. It would seem that for him the key problem consisted in understanding and explaining why the current abandons a rectilinear course and tends to become tortuous, and why perturbations in the shape of waves appear on the surface. These waves seem to be stable, so that the motion of the water particles follows their profile and makes a constant angle with the axis of the current similar to that made with the ship wake by the waves at the bow of a ship moving in calm waters.

Leonardo called this phenomenon "columnar waves" and put together a large documentation on them (page 37). Realizing at once that its causes were many

and were complicated by their interaction, he thought it wise to collect information on many different aspects of the phenomenon so as to give himself the chance of establishing, through studying them, a common law. Codex Madrid I contains some of his studies on this, but most of them appear in Manuscripts B, C, and G.

The sight of the sea was most suggestive to Leonardo. His fleeting visits to Genoa in the retinue of Il Moro were followed by his stay in Venice, by his visits to the Adriatic during the Romagna campaigns with Borgia, and, finally, by his stay in Piombino. His attention was held particularly by the motion of the sea waves breaking on the shore and by the sight of those reflected by the beach, which move

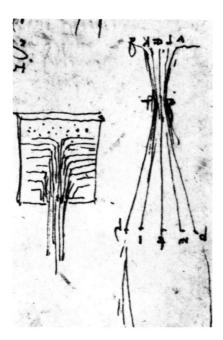

In order to observe the motion and paths of liquid particles issuing from a container, built of glass plates set up closely to one another, Leonardo suggests adding some small seeds to the liquid. He now sees that the particles do not all issue forth parallel to the axis of the outlet, that they also move from the side towards the opening (sketch at left), and that the outflowing stream is first contracted and then expanded (sketch at right). This latter sketch is accompanied by letters for which an explanatory text is lacking – perhaps it was on an opposite folio now missing.

seaward and are superimposed on the incoming waves. This phenomenon suggested to him the laws of the independence of wave motions and of the specularity of their reflections. According to these laws, which constitute Huygens' principle (1673), each point struck by a wave becomes the origin of a new concentric disturbance, and the interference and superposition of all these perturbations determine the configuration of the advancing wave front. This and many other observations are collected in the Codex Leicester, which can be considered a huge index of queries and arguments on practical hydraulics in canals and rivers, on wave motion, and on problems of fluid flow and its measurement. We find repeated here the measurements of the speed of flowing water by means of floating shafts kept upright by appropriate floats and ballasted at their lower end so as to keep them in an almost vertical position, shafts that were to be called "reitrometric" (flow-measuring) by Bonati, an 18th-century scholar. These shafts, still in use today, were later attributed variously to more recent scholars than Leonardo, as Benedetto Castelli and Father Cabeo of Ferrara, but perhaps they had already been used for some time by the hydraulicians of the Po valley,

The windups of currents in rivers and canals were another of Leonardo's preoccupations. He tried to explain why the current would abandon its straight course and form waves that made a constant angle with the current similar to the waves at the bow of a ship. He called them "columnar waves" and made many drawings such as these, which appear in Manuscript F, folios 90 verso. 90 recto. and 47 verso.

The power of ocean waves crashing upon the shore also interested Leonardo. During a visit to Piombino, where he designed new fortifications in late 1504, he made the sketches of waves above in Codex Madrid II. folio 126 recto, and wrote: "Nothing is carried away from the shores by the waves of the sea. The sea cast back to the shore all things left free out at sea. The surface of the water keeps the imprint of the waves for some time." He went on to describe the way the waves broke on the shore and bounced back atop the incoming waves. His description correctly guessed the laws of wave motion. These laws constitute Huygens' principle – each point struck by a wave becomes the origin of new disturbances and all these perturbations determine the shape of the advancing wave front. They were not formulated until 1673 by the Dutch physicist and astronomer Christian Huygens (above).

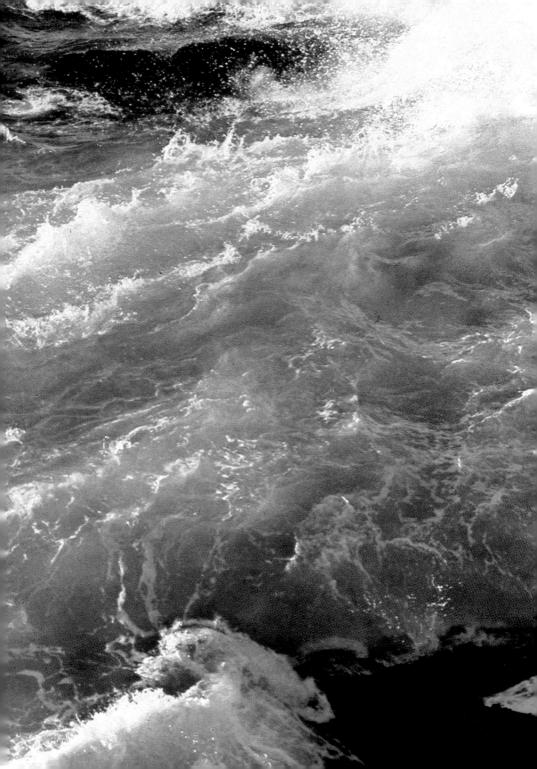

from whom Leonardo may have borrowed the idea, which he found wise and practical. He himself does not take any credit for their invention.

But he had also conceived other devices to measure directly, besides the speed, the "power" of both air and water flows. This is proved by an interesting device consisting of a fan-type wheel with many blades, braked by a counterweight hanging from a rope wrapped around its axle (p. 41).¹⁴ How and how much this device may have been of use to him is hard to say. On the other hand, it is almost certain that Leonardo was the first hydraulician to busy himself with flow measurements based on discharge cross sections and exit velocities. The crowning piece of his research in hydraulics belongs to his second Milanese period, during the French occupation (the time of his notes about the "true" ounce of water" in Manuscripts F and I), to which also belong his last grandiose projects, culminating in the study to provide Milan with a waterway connecting it with Lake Como and the Alpine passes of Spluga and the Engadine (something which could not be achieved through the Martesana Canal because it came out of the Adda River too far downstream and at too low a point) (p. 47). Leonardo first thought of using for this purpose the lakes of the Brianza (p. 42), but then his attention became focused on the idea of a dam on the Adda at a point about 2.5 miles above Trezzo, immediately below the bridge at Paderno (pages 43-45). Here lay a natural gorge - the Tre Corni under the Rocchetta a Santa Maria – created by a massive formation of conglomerate rock, resistant to water erosion, which made navigation absolutely impossible for large barges (48-49). The course of the river could be dammed by a stone dike about 90 feet high, set against the rocks of the Tre Corni. A large lock would be built on the hillside of the valley, in the conglomerates, which would allow the navigational surface to be lowered (by means of a tunnel passing under the Tre Corni) to such a level that Milan could be reached without any further locks. This was the final solution of a problem under discussion for decades - from the time of the Sforza, when the Martesana Canal was proved insufficient for the purpose.

The project as envisaged by Leonardo was too grandiose for his time: even the discharge via a tunnel closed by a sluice gate presented a number of problems not easy to overcome, whose confrontation was bound to stop dead the available technology. But the project, perhaps on account of its boldness, remained in the minds and hearts of the leaders of government in Lombardy through different successive regimes, and was never completely abandoned. It was taken up again after the reoccupation of Milan by the French after the Battle of Melegnano: Leonardo himself, who was already in France, recommended to the king the

names of technicians capable of realizing this project. On a much smaller scale the project was finally completed towards the end of the 16th century, but because of the limited sections adopted and the reduction of the necessary works for the main lock, it never had the economic importance envisaged by its original planners.

This was the last of Leonardo's great hydraulic projects. However, his wellestablished fame caused him to be consulted also on great problems of swamp clearance. He was entrusted by Giuliano de' Medici, brother of Pope Leo X, with the clearance of the Pontine Marshes, and he illustrated his proposed solution in a beautifully colored drawing. Even though his proposal could not lead to a final solution, it was realizable even from an economic viewpoint. Finally, Leonardo studied for the King of France the systematization of the plain of Romorantin by

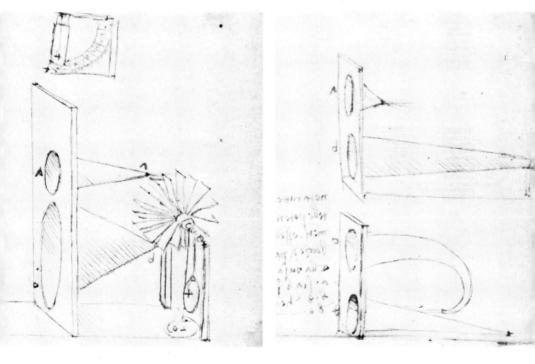

In Milan the government sold water by the "ounce," a crude measurement related to the size of the outflow opening. The imprecision often led to arguments and litigation, and Leonardo may have been called upon to settle the issue of how to measure an exact "ounce." Above, in the Codex Arundel, folio 241 recto, he sets up an experiment for gauging the increased flow in openings with areas reduced by the use of cones. He rigs an anemometer with vanes to make the first known flowmeter. The last great hydraulic project undertaken in Milan by Leonardo was a plan to provide a waterway from the city north to Lake Como and the Alpine passes of Spluga and the Engadine. The existing Martesana Canal could not be used because it left the Adda River too far downstream and at too low a level for navigation. Leonardo, now in the employ of the French who had deposed Lodovico Sforza, first proposed the route for the waterway shown here in the Codex Atlanticus, folio 275 recto-a. This plan utilizes the course of the Lambro River (top of the map) and the lakes of the Brianza to reach the Lake of Lecco and then Como. But Leonardo soon discovered that considerable differences in level would necessitate construction of a number of locks. Typically, he turned to the more innovative and intriguing plan shown on the following pages.

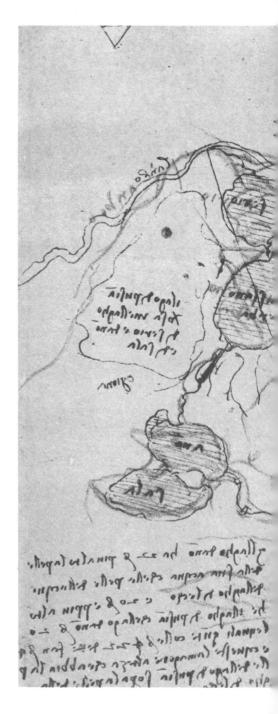

A p estermight in an A C C 2 might City City Con cledingut infreme 18 5 100 bown to week were a A Prique tenbo (nue to hole. the la try calle will a laint cal there is will build an event North Control (State) Anyma 141 Ally Arba 65fissent will build the felor form to partine service and the construction of the property of the A so pupped to the product of the 8 to a spudning 2, MAND 15 5 18 odgand 0 900) 6 Aland may F?

In order to construct the foundation of the stone dike below water level, Leonardo proposed the stake frame shown below. Usually such stakes are rammed into the sandy river bed. Leonardo, however, had to somehow attach them on the rocky ground; therefore, the log frame connecting the stakes had to be stable.

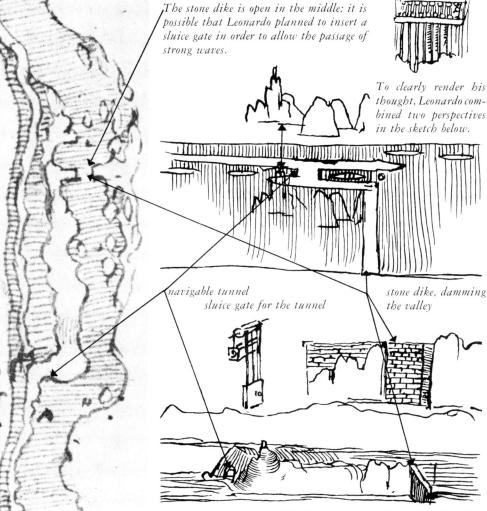

The line drawings above are taken from Leonardo's folio reproduced at right.

on pride to und vi burucio del un HADTA MI mouno filminonghe .8. sois 11176 sels be onklan S SNP SAMA HI ADAYS weat an (A MAN 1: ma

The key to the route Leonardo finally chose for the Milan-Lake Como waterway was a stretch of the Adda River that offered a seemingly insurmountable challenge. The map on page 43 right, in the Codex Atlanticus, folio 335 recto-a, traces this part of the Adda from Trezzo at the bottom to the lake port of Brivio. At the center of the map is the Tre Corni. a natural gorge created by a huge rock formation that made navigation impossible to all but the smallest barges (far left). To bypass the rock, Leonardo proposed the complex plan sketched here in the Atlanticus, folio 141 verso-b: a 90-foot-high stone dike to dam the river; a large lock on the hillside to adjust the surface of the water; diversion of the water into a navigable tunnel with a sluice gate under the Tre Corni. In this ingenious manner Milan could be reached without building additional locks.

regulating the Cher through the use of a dam with movable gates, "like those that I recommended in Frigholi," notes Leonardo.

While he was busy with the conception of the dam on the Adda, Leonardo became steadily more interested in the rotational motion of cages made of thin spiral pipes and loaded by water from above, the *cichognole*. Probably he was pushed in this direction by the increasing use by industry of water power. Leonardo had previously designed waterwheels with radial blades for low heads. Now he adopted the principle of reaction, clear to his mind even in its aerodynamic implications, in numerous applications involving *cichognole*. The arrangement of these spiral tubes - which repeat in many ways the Archimedean screw, even in the uses to which they were put - may seem strange. It is repeated in many versions, usually in couples of spirals, one on the outside which is the driving element, the other on the inside (of smaller diameter) which is the driven element. The first utilizes the fall of water, while the second lifts the water to a greater height. It is not clear what was the purpose of Leonardo's research, since his related sketches have no captions. In any case, one should not infer from them that Leonardo ever gave up his conviction that perpetual motion was an impossibility. These thoughts of his may rather be related to the determination of power of waterfalls on which he had been working for a long time and, in addition, to the couple of the reaction forces due to the outflow which created driving and resisting moments with respect to their common rotational axis.

These studies are particularly interesting because they show us that Leonardo understood and applied the jet reactive thrust more completely than was done in the windmill of Heron. In Leonardo's driving *cichognola* the liquid accelerates while falling, with a motion analogous to that of the water particles in a modern, highly reactive turbine; moreover, as the water accelerates and increases its thrust on the lateral walls of the spirals, the radius of curvature of these increases, thus increasing the lever arm of the reactive couple. Newton's third law (1663) appears here to be thoroughly understood and applied. On the other hand, from the surviving sketches it would not seem that Leonardo ever proceeded from these graphic schemes to scale models: the technology of the time was not yet sufficiently advanced to allow effective and conclusive experiments.

We may consider these to be the last theoretical studies of Leonardo in the field of hydraulics. The development of the wide series of case histories in the field of practical hydraulics contained in the Codex Leicester stopped at the enunciation of principles, which were already the fruit of a long and meditated harvest of observations. Even if these studies contain theoretical implications, which are of the greatest importance even to our eyes, it does not seem that Leonardo followed them up: he stopped at these schematic sketches and at the small notebooks called today the Codex Forster, which only contain ideas going back to his second Milanese period. They are not taken up or repeated anywhere else among the abundant graphic material which can be dated to the last years of his life in Rome and in France. This seems to be also the fate of other lines of Leonardo's thought. Perhaps the search for the goal he had in mind seemed exhausted to him at a certain point, and, as was customary with him, he abandoned it because it no longer held his interest. This was a characteristic feature of Leonardo's personality which might explain why he left so much work unfinished in his legacy, something he has often been reproached for by posterity. The source of this attitude may be found in his permanent anxiety to do new research, an anxiety that was the sole motivation of his superhuman activity. Once his curiosity was satisfied, once the causes and the solutions were found, even if the device invented to conduct the research was incomplete, it became unimportant to build it in its final form. Time was too precious not to devote it to other goals: there was so much still to be brought to light. Leonardo always viewed subjects in the large, in their fullest scope, displaying the same universal vision that in the end had suffocated Greek scientific speculation. The fullness he sought could be encompassed neither by the knowledge of his time nor by the capacity of one man's life.

This map shows the route of Leonardo's proposed waterway: from Milan along the Adda, tunneling under the Tre Corni (following pages, encircled on the map), and into the Lake of Lecco and Lake Como. The project as envisaged by Leonardo was too grandiose for his time, but the project, perhaps on account of its boldness, remained in the minds and hearts of the leaders of government in Lombardy.

Overleaf:

In the course of surveying the Adda for the Milan-Lake Como waterway, Leonardo made this drawing at the Tre Corni where he wanted to build a dam, lock, and tunnel. To the right rise the steep rocks of the Tre Corni, which prevented large-scale navigation. At the far left, next to a house, are the ruins of the old fortress Rochetta a Santa Maria.

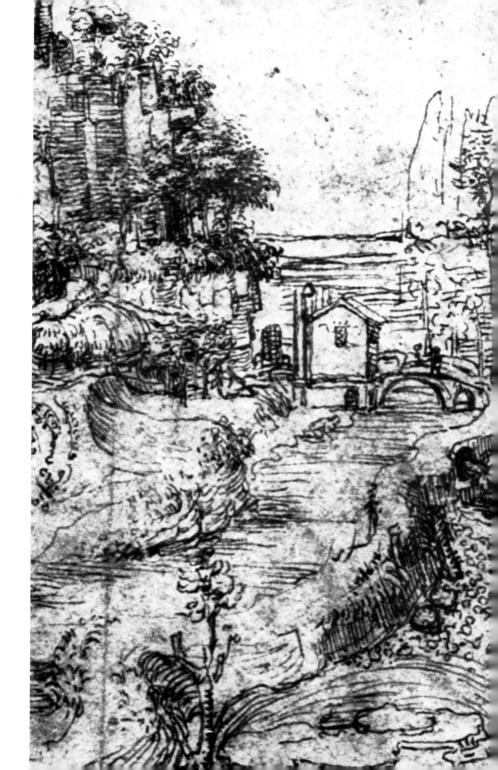

When Leonardo took the post of ducal engineer at Milan, even though this position was at first of secondary importance, he became sensitive to the appeal of the great construction problems which were essential to success in his new post. Until then Leonardo had lived on the fringe of that world of builders which had made of Tuscany a school of daring achievement in the field of large vaulted roofs. Brunelleschi's dome of Santa Maria del Fiore, the Duomo of Florence, completed just at the time of Leonardo's birth, was an example of constructive genius, hard to emulate and the likes of which were not to be found anywhere else (p. 51). But Brunelleschi's achievement had also raised problems of size. His solution could be considered optimal as far as structural stability under loads and thrusts and economy of masonry were concerned; but other similar attempts had failed. The nave of the enlarged Cathedral of Siena, although different in its proportions, repeated the failures of the first proto-Romanic vaults in the Po region of Italy immediately after the year 1000.

The great builder in Florence had been Filippo Brunelleschi (1377–1446), whose work in mathematical proportions and perspective influenced both the painting and architecture of Leonardo. Brunelleschi's magnificent dome for the cathedral in Florence is shown on the opposite page.

Another powerful influence on Leonardo was the architect Donato Bramante, portrayed above in a sketch by Raphael. Bramante settled in Milan about the time of Leonardo's move there and was working on the church of Santa Maria delle Grazie, while Leonardo was painting the Last Supper in the refectory of the adjoining convent.

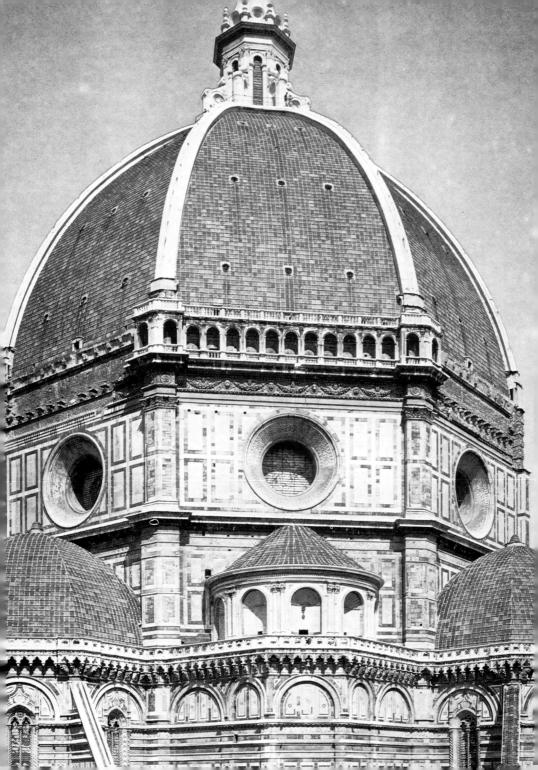

It may be proper to notice here that the building techniques, when they were revived in the West seven centuries after their disappearance in the East, took up again the general types of solutions based on the use of the three fundamental structural elements: the column, the beam, and the arch (which by translation give origin to the wall, the floor, and the vault). But the techniques used in building two of these elements had changed considerably. The beam was unchanged and made out of wood, as always, and the same was true of the floors. But the column and the arch were built in a completely different way. All clay elements had disappeared and above all the classical sesquipedal brick (1.5 feet long), which together with pozzolana mortar had deeply influenced Roman building technique in the first centuries A.D. when it became truly monumental. In their place came the hewn stone, taking advantage of the fact that in the region of the Lombard lakes at the foothills of the Alps the Liassic limestone and the gneiss appear in parallel strata, which are easy to split. So much so that the new building technique, so reminiscent of that developed in the Syriac Orient before the Arab invasion, was called comacina ("from Como") even in referring to structural solutions (unless this name refers to builders in the western Mediterranean who were refugees from the Commagene).

The column and the arch, when thus built without relying on a material with the high binding properties of pozzolana, presented many connection problems. But it was the arch that gave the builders most of their troubles, just as it had at the time of the great achievements of imperial Rome. The magnitude and direction of the arch thrust (which depend on the span-to-rise ratio of the arch and the loads on it) were the unknowns, which the ancient and the medieval builders estimated on the basis of traditional experience, of techniques handed down from generation to generation, and of their own intuition. Ignoring aesthetic considerations - which, if ever, came into play much later (for instance, the tendency to verticality) - the great builders' guilds beyond the Alps had adopted the ogive for both arches and cross vaults (vaulted with arches supported by ribs) for the specific purpose of reducing the magnitude of the horizontal thrust at the haunches, which jeopardized the stability of the roofing of the nave through its tendency to overturn the pier supports. Flying buttresses had been used to displace laterally and to lower the point of application of the thrust, and the weight of pinnacles and spires had been utilized to verticalize the arch reaction so that it would be contained within the base of the piers. As shown by the failure of the Cathedral of Siena, these developments were never thoroughly understood in Italy, nor did similar developments take place there which could be compared with those in northern France, from the Rhine to the Atlantic, and in the British Isles. These developments enhanced the knowledge of the builders beyond the Alps and ensured them a solid store of safe empirical rules, which were the secret of the individual guilds and a means of economic pressure on their customers. Yet though these rules were little, if at all, known in Italy, they were nevertheless empirical rules, and Leonardo must have heard them mentioned in the artistic circles of Florence, where the work of Brunelleschi was still the object of discussions and arguments.

Leonardo must have brought up these Florentine arguments with the ducal technicians at the court of Il Moro and compared them with the opinions of the most important architect of the Sforza court, Bramante (p. 50). Probably spurred on by the knowledge of the latter, Leonardo must have often wondered how to attack the arch and vault problems. Actually his attempts at solution were unsuccessful, but by mere intuition he got only one step away from an approximate geometric solution adopted four centuries later and obtained by the method of the funicular polygon (p. 56).¹⁵

The idea of subdividing the arch into a number of blocks may have been suggested to him by the very construction of arches in stone voussoirs. However, he used this idea by referring back to his research on the equilibrium of wedges ¹⁶ between two inclined struts (p. 58). He actually obtained the horizontal component of the reaction of each voussoir by means of a geometric construction based on the cosine of the angle between the corresponding radius and the horizontal, as if each voussoir behaved like half of one of the wedges he had considered previously. To establish equilibrium he considered the rotational tendency about a support point: the moment of the weight of a body must be balanced by the moment of a "counterweight," as in the case of some balanced triangles and rectangles considered in Codex Madrid I.¹⁷ It is important to realize that these considerations are mistaken only because they are incomplete, since, besides the rotational equilibrium about a support point considered by Leonardo, one must also guarantee translational equilibrium (p. 57).

At this point it would seem easy to us, equipped as we are with a knowledge of graphic statics, to take the final step and reach the solution by (1) evaluating the component of the weight of each voussoir in the direction normal to one of its faces, (2) finding the resultant of this component and of the thrust coming from the keystone, (3) applying this resultant tentatively to the center of gravity of each voussoir, and thus (4) obtaining an approximate understanding of the direction and magnitude of the force transmitted by the arch to its haunches.

carry out the experiment

Weight m will exert upon counterweight n as many different exertions as its positions are varied when shifted along the beam. It is indeed evident that n will suffer a different exertion when the weight is at h and when it is at a.

Rope b c will sustain as many different weights as the sites where the rope is tied to the beam are varied. If the rope is tied at i, the weight of X will

become very heavy for the rope, and if the rope is tied at q, the weight of X will diminish greatly.

The Renaissance builders revived ancient construction techniques based on the three fundamental structural elements - the column, the beam, and the arch. Of these the arch, which was essential in constructing the huge vaulted domes such as the Duomo of Florence, presented the most difficult problems. Instead of the brick used by the old Roman builders, Lombardian architects worked with hewn stone found in abunddance in the foothills of the Alps. The drawings on these two pages - Codex Madrid I, folios 142 verso and 143 recto - show Leonardo attempting to arrive at theoretical solutions to the problem of arch stability. He splits the arch into individual voussoirs wedge-shaped stones - of equal weight. His calculations indicate that he came close to realizing the modern method of determining the horizontal thrust in the arch.

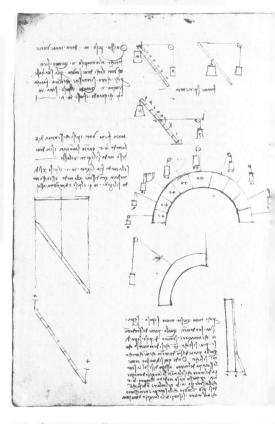

As the entire wall rests on its foundation, that part of the foundation which is loaded with more weight sinks more. And, conversely, that which receives a smaller load sinks less. Hence, it is here demonstrated that the batter of the wall supports only the outside of the wall, which has the thickness of only a single stone. For this reason, as the wall sinks, wall b c will not correspond to batter a b. And as the wall will sink more than the batter, it is necessary to make the wall shorter by the width of one stone.

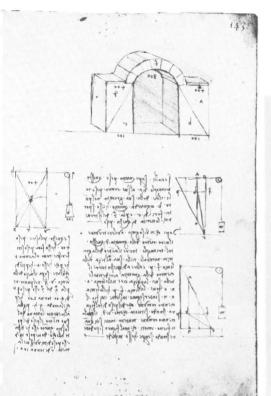

If this pilaster weighs 400, such a weight corresponds entirely to center t. And because t is perpendicular upon the center of line v X, at point r, according to the 9th of the 7th, weight t from 400 becomes 200. And because rope q h is attached at the same distance from its center – the weight of the pilaster – as this is distant from the place where it rests, at v, that weight is diminished by a half, becoming 100. If you wish to know the weight which this triangle imposes upon its counterweight, take the center of its gravity at point b and see how great is its projection beyond c. According to the seventh of the ninth, you will find the true amount of this weight.

You must know, that in order to find the true center of gravity of this triangle, you have to take the center of the natural gravity at the height of line f p. Furthermore, you must take the center of the accidental gravity at its width, that is, line a n. And where line f p intersects line a n, there will be the common center of the weight of such a figure, placed as you see it. This center will change to as many places as are the motions which you can impart to such a figure, provided it remains always upright.

Italian builders never thoroughly understood arch constructing developments taking place north of the Alps where, as in ancient times, techniques were handed down from generation to generation and a builder's own intuition came into play, ensuring individual guilds a solid store of safe empirical rules. Although these rules were little, if at all, known by Italian builders, Leonardo must have heard them in discussions and arguments among the artistic circles of Florence.

An enlargement of Codex Madrid I, folios 142 verso and 143 recto, follows on the next pages.

ON: No by . w. Sun . Hun . Hun . which e v connube . u. on mun . . the pure stores for funder . Jola fundals pol: guno fronofer: gentina funga J. . Sedworks . Smith . w. v. אמווט ליניחס ליחיו יוחילו כלי לי איואית איא Trents be gure furnin 1 in bus holla conser letogone nellelle Leftreonder fre fre fre un un star for x Val 0+ 0-0vdo vale ounu. of mo oun . Sod In. fon somer . quale . port Silfonsam G. vdo . ofor b. swind . : svorbunu : b. et to of it will be to the sound of the Builly mouse bills during a dimiced on the me Vyde Out and When bur come (Alexing de locardo - Alega Ale al (Alean A Alexing de locarde ra alexing and a second and a second and a second and the angle of a could and as a second and the angle of a the firm of a second angle of a second menor of the muno . (Corres & the tanges a Bunana

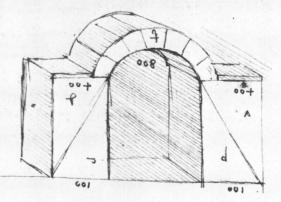

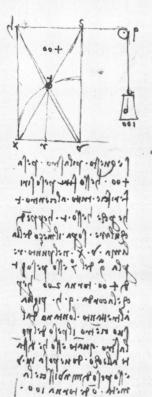

enory . Osd. ouwnorder . Wiens privado . Ju. y was canev belo . 10 (1. sters fully (av Grante welps red . of - adwind . John Do . 0, 04 אותי לעוצ אי כ - כי אל איין איין איין אייניאני surgery susjedy . What of 13 H: 30 idu C 1 mino - actro Anta growing . & quillo . we the worker . towns store the film and Min manurale nella . Jun Alt. 20 nella uma.f. p. color: A gail to torn: il usuno fela grante an fentale n. c Jone. Whink . t. p. pellahma v. u. fruter leano. n' fen: in tre il Tample Protomogo MANNI . ofman כו חורים כסיוולאז . זמאריאר יוחורו (וון פאר H freno . mon . el: attal figure (100 Par shopen u of sand of why ...

11

Leonardo may have been prevented from taking this final step by some conclusions he had reached in accordance with the rules and propositions of mechanics, and in particular of statics, which he had shaped into a systematic body of theoretical knowledge before his dedication to the physical interpretation of mechanical phenomena. It is impossible to establish whether this set of rules was carefully written down or merely jotted down in note form and then elaborated as time went on, given the present state of the Vincian manuscripts that have survived. However, various heading lists of the books on mechanics that Leonardo planned to write have been preserved; and it is certain that the references he makes in his discussions to numbers of chapters and propositions are as precise as if he were referring to an already definite compilation.

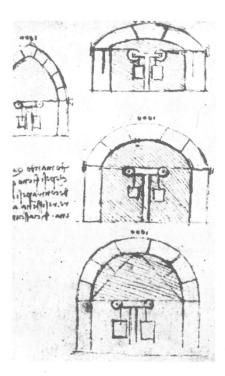

Pages 58-60:

Arches used as structural elements often collapsed and no one, not even Leonardo, was quite sure why. In these drawings he attempts to establish rules for the stresses that cause failure in arches. In the Arundel sketches (middle and far right) entitled "On the breaking of arches," he uses a chain as a tie rod to absorb the horizontal thrust acting upon the supports. Tuscan architects believed that such chains were the solution to the problem of arch stability. Actually, chains often failed because builders lacked the theoretical knowledge needed for proper sizing and anchoring. Though he failed to find another solution, Leonardo observes, "The arches which are held together by means of chains will not last." He was also able to prove that a masonry arch would fall under a concentrated load applied off the crown of the arch, while it would sustain a load at the crown.

IYA

INA

Ach

1nd

Among these propositions, one to which he refers in Codex Madrid I when discussing the stability of arches and vaults reads as follows: "That part of the disunited weight burdens more, which is nearest to its center of gravity."¹⁸ In other words, that part of a distributed weight which is nearer to the vertical through its

centroid exerts a greater pressure. Of course, this is not true when, in addition to vertical forces, moments are present which shift the line of action of the forces. In fact, acknowledging the rule by means of an example on the same folio, Leonardo concluded erroneously that an arch representing the main section of the dome of

Setta perry mgol of:gras UNN BOARS An. ACHIEN . th pulve Games ind in has S. MARDING SA begs at more aptons . v. o. p. madine wo C inter condo tori 1 an . w. a. Capart tellofran Re Gater - par 1 HADOR MOMINA . dia 4.10 an: unclo.cf. MANA . AN' IP SM WAR W. WOMMO WAN . AN DOCHAL . AN Meth- INA- MAR (Arces Huptice 19:00 1.05 oher · 80 \$ O. unsiste HIM Ge CAN CEO. C (Opratio Quil patal beelto. ut tadoiona.c.d cold - - Ator grade patoro. a.1 CANER E. dia Prito Prin (Archerole M'A NY' ZU

the Grazie in Milan, weighs more on the inside edge of the center ring support (i.e., at the intrados of the arch) than on its outside edge (i.e., at the extrados of the arch). The partial double coaxial vault of this dome had in fact the sole purpose of widening its base support and of increasing the weight of the lower part of the

dome only so as to bring nearer to the vertical the force resulting from the thrust and the weights of its upper part and of the lantern.

As also shown by this example, Leonardo seems to attach no importance to the horizontal thrust of the arch as a factor critical for its stability. His stand on this question may have been due to his awareness of the use of tie rods, first introduced in arch construction by Tuscan architects. Applying this tensile element to the arch, these master builders believed they had solved once and for all the problem of the horizontal thrust on the arch haunches and could therefore consider the arch as hinged to fixed supports. Actually this was often a mistaken assumption, because they lacked criteria for dimensioning the tie rod cross section and for anchoring it correctly to the masonry so that the supports would be practically fixed. In any case, the phenomenon of arch failure was always considered by Leonardo for the case of fixed supports (left), and was assumed to consist of the splitting of the original arch line into separate sections corresponding to the various pieces into which the structure breaks up. From the geometric constructions he seems to use in trying to establish the nature of the stresses causing the arch failure, one would be led to think that he sees the failure as resulting from a bending moment which develops at the point of application of the loads. But there is no mention of this explanation in the text next to the figure. Perhaps Leonardo planned to discuss this point in the mathematical treatise he promised in Codex Madrid I to write.20

Perhaps he would have also explained in this same treatise why in a frame made of two posts and a beam the posts bend outward and the beam bends inward, i.e., downward, as stated in Madrid I;²¹ but at the time Leonardo only made this statement without going into a quantitative analysis of it.

On the other hand, in considering the deformation of a bent bar, Leonardo succeeded in this codex in describing exactly the phenomenon due to the stressing of its fibers under the heading "Of bending of the springs."²² There he clearly realized that (1) the inner part of the bar (facing the center of curvature) shortens, i.e., the inner fibers are compressed, and (2) the outer part of the bar lengthens, i.e., the outer fibers are tensed, so that (3) the length of the middle axis of the bar remains unchanged, and (4) the lengthening or shortening of the fibers is proportional to their distance from the middle axis of the bar (p. 62).

This is the exact scheme of longitudinal stress distribution along the depth of the cross section of a bent elastic body that was hypothesized, amid much controversy, 200 years later (in 1705) by Johann Bernoulli (p. 63). On the basis of his

Beth pic gatara fillimith כ איכוי היו אינא - פי איפיי pisganto : lamol quakril the cargatia parts fill no col mo all firmitide etals. purp folgane staff consel (ADIA A MAR HORE A AD OR Norwell . Out lik mother of va miss riffermolle nonfie ili worden . wording in w the motology minime muth fith mutchen: com: film High of Commer & art nome En A: UN LANCEN - - DOI DIE souto Car malle in moto of: Allescaletto a.p. (with the איים כיון אויט לעייול כיון איום Citty of imme orifain the guinio davin - Un li. dual up in when out ilmeson an here affat is an (nh nblo hullenere chink מרום ל (הכומו לי (ינו או יי (י We when hudwy . While w די הופחשי מושחתהה אומק שט lidebding ha trut his We cow! יליחייני אילה לרין ה לק אר קחריהל: milter the swinip un a mindiger with mello bit m: MADO

Of bending of the springs.

If a straight spring is bent. it is necessary that its convex part become thinner and its concave part, thicker. This modification is pyramidal. and consequently there will never be a change in the middle of the spring. You shall discover, if you consider all of the aforementioned modifications, that by taking part a b in the middle of its length and then bending the spring in a way that the two parallel lines. a and b, touch at the bottom, the distance between the parallel lines has grown as much at the top as it has diminished at the bottom. Therefore, the center of its height has become much like a balance for the sides. And the ends of those lines draw as close at the bottom as much as they draw away at the top. From this, you will understand why the center of the height of the parallels never increases in a b nor diminishes in the bent spring at c o.

Leonardo was far more successful in searching out the behavior of a bar or spring under stress. In Codex Madrid I. folio 84 verso (p. 62), he describes the mechanism of a bending spring with uncanny accuracy: the fibers of the spring are lengthened at the outside of the curvature and shortened at the inside: the fibers in the middle are not deformed: lengthening and shortening occurs in proportion to the distance from the undeformed middle fibers. When this hypothesis of internal stress distribution was stated more than two centuries later by Johann Bernoulli (left) - the father of Daniel Bernoulli – it became the basis for the modern theory of elasticity.

hypothesis and with the help of the calculus Bernoulli was able to synthesize the resistance of the cross section of a bar in its "moment of inertia" and to relate to it Hooke's law, "strain is proportional to stress," which is the basis of the modern theory of elasticity. (Let us note, in passing, that Galileo thought the entire cross section of a bent bar to be in tension, as stated in the *Trattato delle resistenze* gathered by Vincenzo Viviani and completed by the abbot Giulio Grandi of the University of Pisa in 1712.)

In this case, too, Leonardo stopped at the observation of the spring behavior; to obtain from it useful results, one needed to formulate Hooke's law and to extend the observation by induction to the general case of a body of arbitrary cross section bent along its longitudinal axis. However, at the time, the notion of an external bending moment acting at a section was lacking, as was that of a resisting internal moment of the fiber stresses capable of equilibrating the external moment.

As far as generalizations are concerned, we are here in a situation analogous to that created by Leonardo's statement on the *potentia* ("power" or energy) from the fall of water discussed earlier in this chapter. This statement is only a particular case of the basic law of hydrodynamics, which in turn represents but one aspect of a universal principle of dynamics: the energy of a system consists of two terms, one depending on the position and the other on the state of motion of the system in the field of forces, which influence its position (Hamilton's principle and the Hamilton-Jacoby equations, 1863). Nevertheless, it is precisely in the passage of

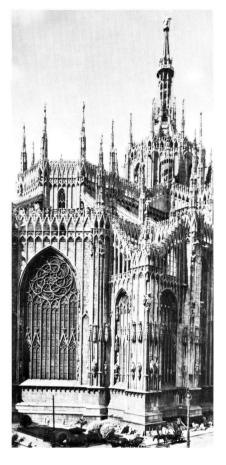

For years the unfinished central cupola of the Milan Cathedral was a source of great controversy. In 1488 Leonardo entered a competition for its design with a plan based on sketches in the Codex Atlanticus, folios 310 verso-b and 310 recto-b (pp. 65, 66). For unknown reasons he later withdrew from the contest.

Leonardo's Codex Madrid I containing this statement that we read for the first time in the history of human thought that energy is a function of position and motion. Before him "gravity" was simply either "natural" or "accidental." Not even Jakob Bernoulli, when he stated his law of hydrodynamics, realized that it was a particular case of a general law of immeasurable significance, since this law could only be formulated when theoretical mechanics and the differential calculus had become so developed as to allow the rational justification of such generalizations. Many similar cases of generalizations in the field of applied mechanics can be mentioned today which were implicit in the genial intuitions of its forerunners.

One cannot expect the appearance of conceptual analyses as complex as those just mentioned at a time when the basic concepts themselves were still quite nebulous. Nor must we forget that although the centuries-old dispute on the "universals"

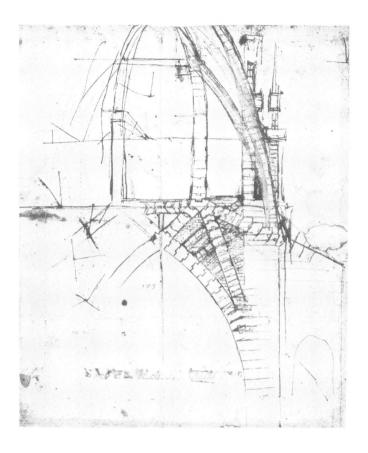

had been practically exhausted at the time Leonardo wrote, it had failed to show how to proceed towards the universalization of basic concepts and contented itself with comparisons and measurements of "greater" and "lesser universality." The process of universalization was accomplished many centuries later by means of a philosophical, critical approach under the impulse of the Kantian spirit. This must be emphasized for us to realize that, whenever he could, Leonardo tried to reach "general" statements in his discussions. In the majority of cases his generality cannot become a generalization, but only the extension to a whole class of phenomena of the observations he made on the concrete case he was analyzing. Generalizations can be ours now on the basis of the additional knowledge we have acquired in the five centuries since Leonardo.

"And thereby to show what is the weight and how many and what are the causes that ruin buildings, and what causes their stability and permanence. But so as not to prolong unduly this discourse to your Excellencies, I shall begin by explaining the plan of the first architect of the cathedral, and show clearly what was his intention, as revealed by the edifice begun by him, and having understood this, you will see clearly that the model which I have made embodies the symmetry, the correspondence, the conformity which appertained to the edifice from the beginning."

Excerpt from a letter believed to be sent by Leonardo to the Works Department of the Cathedral of Milan together with a model of his proposal for the cathedral's central tower.

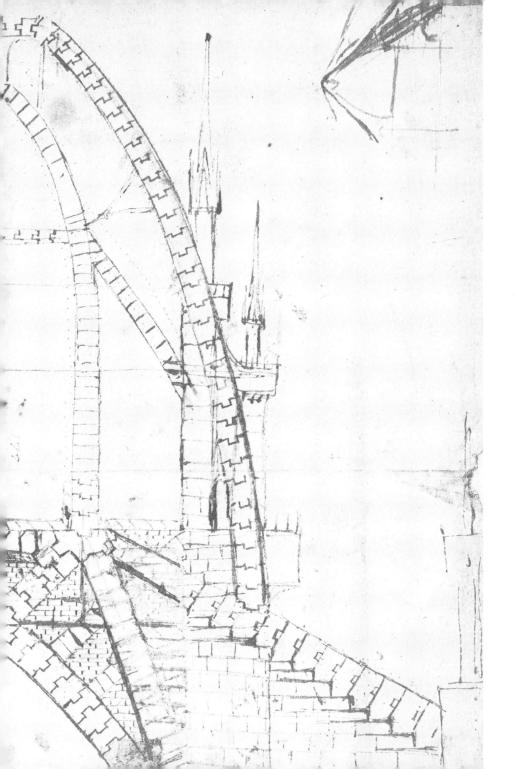

"... a splendor that can only shine briefly in a word, in a sentence, or in the space of a few lines, and yet leaves a profound impression on the reader."

LEONARDO'S WRITINGS

AUGUSTO MARINONI

Leonardo wrote, sketched, and painted with his left hand, and most of the entries in his notebooks, even his own signature, run right to left in a seemingly mysterious mirror writing. Here, his letter I is written with a flowing artistic elegance.

The most substantial Vincian manuscripts are today in Italy, France, England, and Spain. Isolated leaves are located in Germany, Austria, Switzerland, Holland, Hungary, and the United States.

In the Biblioteca Ambrosiana of Milan in Italy is the large collection of over 1,200 folios of various sizes that the art collector Pompeo Leoni in the 16th century pasted on about 400 large folios of an album to create the Codex Atlanticus. (In recent years Leonardo's drawings and writings have been detached from the album of Leoni and have been restored and remounted in 12 splendid volumes.) In Milan too, at the Biblioteca Trivulziana, the Codex Trivulzianus is kept; the Biblioteca Reale of Turin has the small Codex on the Flight of Birds; and in the Galleria dell'Accademia of Venice there is a group of drawings.

Besides the very rich collection of drawings in Windsor Castle, England possesses the Codex Leicester, the Codex Arundel of the British Museum, and the 3 Forster Codices of the Victoria and Albert Museum of London.

ricgordo delas Reo la Reio par notallone . Ro A Sarge Valle (nofama -1 1 vion oreit » (מכוענע mayorn: "(האימט MANY ASTAR ronwinon a to Supure Supuro ANTONS MOTIN nor Mine & millingon Aldaid o's to from Atom of 100 oning rige pumo profitering as mining 18: PARTA propolitions from porced rlog at an 19: PATIANA ANONAPSINOHIS ANINO ANAMAMANOM ONV (CO Arroll A Pord la FORMA 12 Antons unmop to to fund a fulster magno OWN inn nutiti clomgag. mogo autor by Or any was pursoniforno ONTO OAN A MOUTH PANA UINDONS feller more his file fellamment 5BASMA interest arramance matter al ormand Willy British & June 10 (Aguadimo &: prof) MYNNAVOI orthe of inter PART problema gamilt ohis n 10+010 (090) AN AMING) PUHUU UPCHALLANUE SITEMAN Mader & making tok (opo ilingue france (e Gener nighted Sibn(Pan: npo Perimi mining ana) forma CHAN SOUNA & MS MORT 1P' ON WAND -P 1'inr and another or and and only and and more such and No and + Mid אואה בזמון לי אי איאוי ב או אוינייו . S MAN SHUMMAN Arm chine avo Rolowa ottoring Aslopin O RINGP'S lotting uprin bulgaring harry NENO a) Privat Att Nor A 12002 That -mont Porna - P. TOW Ativismonia Minh 1 tomain stammertor ATT PAR ANNAN MORAL PAGE Prefino prideo tal ancino intra (Rang Mannie לילה אויז אוי איי איי לילי לידיו אייים oneth for and my chang 787 11 17 6974 Margona graning 010 Locupoli for summing allow nterates propolation opendar of all Concers may qualpare, believed UNINAN AS OF MINTS Anotomn

The French holding, in Paris, consists of 12 of 13 manuscripts that Napoleon removed from the Biblioteca Ambrosiana. They bear the marks A, B, C, D, E, F, G, H, I, K, L, and M (the two Ashburnham Codices are part of Manuscripts A and B, from which they were torn out in the past century).

We have known only for a few years that the Biblioteca Nacional of Madrid is the home of the two important manuscripts Codex Madrid I and Codex Madrid II.

us and u gallen main musically i making a ma al Raimana) pire mon p arresto 12 50 A SHO HHANNY AMAANNARYP 10 OHANNO TO Apitry 10 The form and the T wind who regole & forme 1 ANTOSP A Miloca Dollary attiganter Repromment T & MAN OM MA OIVNAR AT UTAUN TO word offering all RA & umadi CONNERATIO tipo proacqu (NAP. Julia 2 culle upwanttenn MW & CUM work champles will all more plane miles & gannel forgampilant town and Handla of analyment of alberty US Afriane scargas monganp (Betto presta privil) mornice INA MANPAND Nodmor Anna Dochook metern iso gampingo manningo mmann incuts unlawn cost phones offin July of add af add (60 gone fraglia (constituant) As annahan filmanalla BEGINAMENT PARM (AND also begu gamie la

The rediscovery of the Madrid Codices reveals the contents of Leonardo's library and yields a clue to the number of his own notebooks. On these two pages from Codex Madrid II, folios 2 verso and 3 recto, he listed the titles of 116 books that he left in Florence when he went to Piombino in 1504. Despite Leonardo's attempts to depict himself as unlettered, the list suggests a well-read person with wide-ranging interests in medicine. mathematics. Latin grammar, and even the Fables of Aesop. In several instances he carefully has noted books lent to friends. Two books in his library, one of "my words" and one of "horses, sketched," probably were by his own hand. But on the following page of Madrid

A book of horses, sketched for the cartoon

Book of my words

II, folio 3 verso, is a second, more tantalizing list (below) – untitled but arranged by physical format, leading to the belief that it may be an accounting of Leonardo's own notebooks. Though the list adds up to 50, Leonardo, the avid mathematician, made a simple error in arithmetic and got 48.

-25 (161 progon) 2 Mermongonn 6 (161 programs) 1 (160 programs)

25 small books 2 larger books 16 still larger books 6 books bound in vellum 1 book with green chamois cover Unfortunately, with the passing of the centuries, the traces of many other manuscripts have been lost. How many we can only guess. Leonardo himself several times records books and treatises composed by him that we are unable to identify among the surviving manuscripts. What became of the "book on painting and human movements" which, according to Luca Pacioli, Leonardo had already composed in 1498, while he was coming to the end of the "invaluable" work "on local movement"? Some of Leonardo's writings undoubtedly ended up in the hands of others while he was alive.

But Codex Madrid II will perhaps enable us to establish how many of his own notebooks Leonardo had in his possession in 1504. In the important and already famous list (p. 70) of 116 books that Leonardo was leaving "at the monastery"¹ at least two items name his own work: the "book of my words" and the "book of horses, sketched for the cartoon." After this list Leonardo inventories² a mass of books of which he gives us neither the titles nor the characteristics apart from the number and, roughly, the dimensions. There are 25 "small" books, 2 "larger" books, 16 "still larger" books, 6 "bound in vellum," and 1 "with green chamois cover" (p. 71). Later, too, it was to be the custom of collectors of Vincian manuscripts to arrange them according to size – this is what Leoni, Melzi, and Arconati did – and as the 50 large and small books that are included in Leonardo's inventory are not part of the 116 whose titles are listed in the two preceding pages, we seem right in thinking that we have here works originated by Leonardo.³

The manuscripts that Leonardo still possessed when he died were inherited and carried to Italy by his faithful disciple Francesco Melzi (p. 73), who preserved them with great care in his villa at Vaprio. He put them in order and distinguished them sometimes with alphabetical letters, sometimes with strange code marks, and added to them some notes on the number of folios present or missing. In addition he tried to do what Leonardo had wanted to do but in fact never did. He carefully read all the manuscripts, marked with an *o* passages related to painting, then copied them into the Codex Urbinas and thus compiled Leonardo's *Treatise on Painting*. Folio 231, recto and verso, contains the list of Vincian manuscripts from which the *Treatise* was taken – 18 in all, of which 3 are defined as "booklets," that is, in sextodecimo. Only 7 of these 18 manuscripts are known today.⁴ The various comparisons that have been made between the original writings of Leonardo and the *Treatise* show the accuracy of the copy and lead to the disturbing discovery that about three-quarters of the material found in the *Treatise* cannot be traced in the

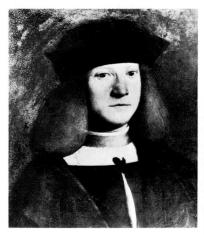

Francesco Melzi

Cardinal Borromeo

Leonardo bequeathed his manuscripts to his disciple and pupil, Francesco Melzi (left), who had remained with the master until his death at Cloux in 1519. Melzi took the works back to Milan, treasured them, and undertook the kind of extensive cataloguing Leonardo always had put off. After Melzi's death around 1570, the dispersal of the manuscripts began and avarice took over – many of the unpublished notebooks passed through the hands of thieves and dealers as

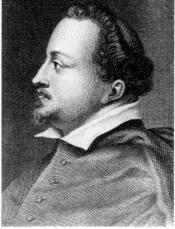

well as scholars. One of the manuscripts wound up with Cardinal Federigo Borromeo (right), founder of the Biblioteca Ambrosiana in Milan, and he donated it to the library in 1609. Eventually, the library's collection included 13 manuscripts, but on Napoleon's instructions they were carted off to Paris in 1796. After the Napoleonic wars, only the Codex Atlanticus was returned to Milan. The rest remained in Paris.

known Vincian manuscripts. This gives a measure of the losses suffered by Leonardo's writings, even admitting that the pages dealing with painting were the most sought after by the artists of the 16th century and consequently more subject to plunder than those related to other subjects.

On the death of Francesco Melzi around 1570 his heirs, especially his son Orazio, ignorant of the value of Leonardo's papers, relegated them to the attic, so that the tutor of the house, Lelio Gavardi, observing this indifference, thought he committed no crime by removing 13 manuscripts that he tried in vain to sell to the Duke of Florence. Remorse for the improper act was stirred up in his soul by his fellow student at Pisa, G. A. Mazenta, who himself undertook to return to Milan the ill-gotten property and restore it to Orazio Melzi. The latter merely reconfirmed his own lack of interest in the booklets and told Mazenta to keep them. Thus it is that the 13 manuscripts were divided between Mazenta's two brothers: Guido, who kept 6, and Alessandro.

Even in the everyday act of jotting down his thoughts and observations, Leonardo's hand was capable of the great artistry that distinguished his painting and drawing. Here, enlarged from various pages in Codex Madrid I, the capital letters of his alphabet stand alone with a simple and balanced elegance – embellished, as in the O and Q, with an occasional flourish. Not all of Leonardo's calligraphy is so elegant. Often he wrote haphazardly, scrawling in haste and excitement in the margins of whatever notebook happened to be at hand, spelling arbitrarily, skipping words and phrases. Indeed, the careful craftsmanship of Madrid I indicates that the author intended to show it to others and perhaps even to publish it. This care combined with the fact that Madrid I is composed in the familiar mirror writing dispels the mystery that has clung to his eccentric penmanship, rebutting the contention that it was a conscious

It is here that the figure of Pompeo Leoni comes into the story. He was court sculptor to the King of Spain, Philip II, and a great collector of works of art. Promising Orazio Melzi the favors of the king and a place in the Senato, he obtained Alessandro Mazenta's 7 manuscripts, but only after 15 years did he succeed in recovering 3 of the 6 in the possession of Guido. The other 3 had already been given to Cardinal Borromeo (the present Manuscript C), to the Duke of Savoy, and to A. Figgini. Just as Melzi had done, Leoni meticulously set about cataloguing the vast material. Having arranged the manuscripts according to

format, from the largest to the smallest, he first marked each with a progressive number, placed at the beginning or at the end of every volume. The highest number among those which have come down to us is 46. Then he wrote, or had an assistant write, an alphabetical mark as well. Of the manuscripts marked by Leoni only 19 remain, which again gives us some idea of how many of the manuscripts have been lost.⁵

But Leoni did not stop at distinguishing each manuscript with a number and an alphabetical mark. What Melzi had done in some cases – note the number of folios contained in the manuscript – Leoni did systematically, adding beside the alphabetical marks numbers corresponding to those of the leaves making up the volume: for example, A 190, O 140, BB 14, LL 48. This is invaluable indication that allows us to establish how many folios constituted a given manuscript in Leoni's time, how many were afterwards removed, and how many had already been taken away.⁶

In the case of the Madrid manuscripts we observe that Leoni wrote the mark A 190 on folio 191 verso of Codex Madrid I. The manuscript had been made up of two volumes of 96 folios each, numbered on the recto in Leonardo's own hand from 1 to 95 with the omission of the first folio, which was at first left blank as a flyleaf, as a temporary cover, or because it was destined to be pasted on the back of the cover during binding. The fact that the two series of numbers 1 to 95 proceed in opposite directions from the beginning and from the end, meeting in the middle, makes us suppose that Leonardo, although distinguishing the two volumes, intended to consider them as two parts of the same work. The fact is that when they came into Leoni's hands they already formed a single volume; and Leoni himself, or one of his assistants or others before him (Melzi?), took care to unify the numeration from folio 95 to the end. It can also be taken for granted that the folios now missing and once numbered from 37 to 42 and from 55 to 56 were lost after the operations carried out by Leoni.⁷

This montage of Leonardo's handwriting shows examples of his small alphabet taken from various manuscripts. In the clusters of individual letters can be traced the evolution of his style of penmanship. The differences are so pronounced that scholars sometimes can date a manuscript to the precise years by studying the forms of the letters. As a young man Leonardo's hand was influenced by the world of merchants and notaries – his own father was a notary – and was therefore ornamental, slow, full of flourishes. From about age 38 to 63 his writing displayed increasing simplicity and speed to keep up with his impatient mind. In the final years before his death it grew heavy and labored.

99.

Besides the bound manuscripts, Leoni gathered together a large mass of loose papers of various sizes that Leonardo had written or drawn upon. The latter – in the interests of economy, we can say – used every piece of paper that happened to come into his hands provided it still had a blank face: leaves from registers, letters, the writings of others. The paper was often of such poor quality that Leonardo could write on one side only, as the ink went through the whole thickness of the paper. Even these isolated sheets have in great part been classified with a progressive number generally placed at the center of the page. However, the fact that many numbers are repeated several times on different sheets makes us think that they came from diverse collections and that they were not then reordered systematically. In order to save such papers from dispersion and to give them physical unity, Leoni thought of pasting them onto large folios of two big albums: one the present Windsor Collection, with the original title of *Designs of Leonardo da Vinci Restored by Pompeo Leoni*, and the other the Codex Atlanticus, entitled *Designs of Machines*

At right are the title pages of the two important manuscripts Codex Madrid I and Codex Madrid II, only recently rediscovered in the Biblioteca Nacional. Madrid. It is almost certain that these two codices once belonged to the library of Philip V (1683-1746), King of Spain. In addition to catalogue markings inside the front covers of both volumes, their gold-tooled red morocco bindings are identical to those of manuscripts kept in the old palace library. It is very likely that when this rebinding was carried out, the manuscripts were also provided with their present title pages.

te la naroo De Vin cris pin tor fa mo Tratado De Estatica y Mechanica En Italiano Escrito en el Año 1493 como se ve ala buelta del fol. 1: Contiene 191 folios y esta escrito al reves

and of Secret Arts and Other Things of Leonardo da Vinci Gathered by Pompeo Leoni. When both sides of the paper were written on, Leoni made a hole or a window in the supporting folio of the album and pasted the edges of the paper so that both sides remained visible.

The discussion of the most startling discovery made as a consequence of the recent restoration of the Codex Atlanticus is contained in the Appendix, on page 154.

For a long time it was considered that Leoni had taken apart and mutilated a certain number of Vincian notebooks in order to make up the Codex Atlanticus. This, it was thought, would explain the disappearance of many notebooks and lead to the reassuring conclusion that these were still present in the Codex

Tratados varios de Fortificacion Estatica y Geometria Escritos en Italiano However, Codex Madrid I (far left) bears at the top of the title page an important note, "de Leonardo da Vinchi pintor famoso," in a 17th century hand, possibly an estate appraiser's. It would suggest that the note precedes Por los Años de 1491 como se rebinding and the editing of the title page. In Codex Madrid II ve à la vuelta del fol. 157. (left) no such identification is found, but here too there had been a previous notation on the Movirtiendo que la Letra de este page; an indication of the number of folios, which was afterwards covered by a decorative Libro está al reves scroll, like the one placed at the bottom.

Atlanticus and in the Windsor Collection, although mixed up and mutilated. But we were mistaken, or we had exaggerated. André Corbeau rightly pointed out that if Leoni had in fact taken apart actual manuscripts, many sheets of the Codex Atlanticus would still show the holes of the stitches and the fold in the middle. But there are no holes, and folds in the middle are not very frequent. The recent restoration of the Codex Atlanticus freed the folios from the superimpositions and foldings to which, in the interests of economy of space, Leoni had subjected them, thus making a more accurate examination of the individual pages possible and leading to fresh conclusions. Leoni certainly permitted himself many arbitrary procedures, such as separating into two different albums two types of drawings and subjects; to do this, he cut out from the interior of various pages of the Codex Atlanticus figures which he arranged in the Windsor Collection, and then patched up the holes he had made. Again,

- Low der (core pineto . Jo: quille . corriona parris ------PINNE m netwers alle and ... pundeste junter partite pundente star Lanca rule rich c bandonus allatino grant nav ch Internation construction of multiple stranders - for anning od an and a superior Junia sunjan affare united Interes brown Just put a proper stillions Kante Att une messe nofue asmant le par a l'altre no dont arcourses a program site, ungolo panno Quinto building niche commina lomment quit DA INVERSION AGA to contact a pose Division advance riche forma loon taluma riche ethe our tan angou formano untradioro equate enaflorna esta tanin ese atalane (opa for ta sene pechetara no nta tame ata quate loon for the GOWNU Street minghan commin The att spice stall. Conquilia magnere detreto fue geoto ottalo Holoud , Ing Harrs יאי ארות אות אישור כוביים ליאיין אישור ביובי ביובי לא אישור ביובי ביובי ביובי ביובי ביוביים ביוב ביוביים l'angolo minore petrectro programa acquero -1 E torray ac be there & antena coop היווציאי ואייאים אונים Sciment lay 2 6 (a fegura hequille Better comenum de prono apo mind sen winthed

Pompeo Leoni, court sculptor to the King of Spain, acquired some 50 Leonardo notebooks and set about arranging them by size, from largest to smallest. He numbered each notebook, then added an alphabetical mark and the number of folios or sheets in each. The last page of Codex Madrid I, folio 191 verso (above right), bears the mark A 190.

A: Kale & goils much minden Amination of antiput of the states + . 10 170 MAMINA HINO . A. F. Q .. HA dipaul g. a. g. fu. 1+ . day man sisman . Hings : fight nomine we digni . combion in more with we clope tamen fra . y. com. Dik. J. S. fr. M. M. turnin. . . . to ++ for 1+ . (Ameron ho .> NAIG 1. 53 . 4. 14 - Lumith . 4. . 2 A 12 : 2. fr. 1+. Comen. 5: > sin 2 · 1 · frant Lametre 190.7 14. Bout a sand where and any on survey was the vilar H'S STE SA mel. -widvy cree crede alfrach mores. in bon ono n "Usho c unilly int: s) SAN C J - : % סבין לכיצולבי והק התני כי איזיהלבי זיזואלביע הלו הידיוביציווית 5. . . אמיני בין קיטראינייבה יוריאט אין יאחורי ביאה ביכטור איאויר illog 15 0: :4 ontin 2. 20. lunip J. 14 1:00 . . 4 . 10 r ' ANT I ามรอบเป็นสาราร เริ่ม กา การกลุ่ม - และการ การกราช allow own supply the second of the second 21. 545 Dod and. 6.5 . : 5. -AN CJ 90 ·2· ·? = ond · 24:60 קעתני האיזיזינים בסיוזי לנחורת כם יווז האל של די וייו לאתר fund: No 23 int the me Incart: Br

The original last page of Madrid II, folio 140 verso (above, left), is marked O 140 (17 more folios were bound on later). Memoria et Nota de 2:141, i popi de Libri di mano Si Iconardo quele compongono in vienne Lo presente info del Trattato di Bionome & Prime 1 libro Intiero segnato . libre scopeto_ A. ct.Z. libro sognato libro d'ombra c'Imme - . G . Scanato -Vn'astro del meserimo Scanato - . W. ibro scomato litro scamato - _ * - A Libre segnato. ____ Xp. lino seguro. ____ B. Sibro segnato. libro segnato . - A . sisro segnato .---- . @. -C't tre altri lifetini I altre scanaco Ci Jalors segnato - - T. -Che sono titti n. xviii.

Leonardo's notebooks were a librarian's nightmare as they passed through the hands of heirs legitimate and otherwise - a priceless but randomly puttogether mass. Francesco Melzi, his pupil and heir, compiled the Treatise on Painting by painstakingly copying all the passages related to painting into the Codex Urbinas. At the end he listed the 18 Leonardo manuscripts that were his sources and gave each a distinguishing mark (above). Only 7 of these manuscripts survive today.

he distributed and spaced out over different pages several folios that probably constituted little quires that were still loose but dealt with the same subject matter. Nevertheless it cannot be said that he dismembered original volumes; on the contrary, we ought to praise him for having saved so many unbound sheets from probable dispersion.

After Melzi, it was Leoni who succeeded in obtaining the greatest quantity of Leonardine manuscripts. He claimed to be buying them up for the King of Spain and in fact transferred to Madrid the treasure he had accumulated. Some writings and titles in Spanish on the Vincian manuscripts still remind of that expatriation. But it does not appear that Leoni offered or promised those manuscripts to the Court of Madrid. After Leoni's death, some were brought back to Milan, others, such as the two at the Biblioteca Nacional, remained in Spain, and perhaps from there a few found their way to England.

Leoni died in Madrid in 1608. Shortly after, another keen collector of Vincian manuscripts asserts himself: Count Galeazzo Arconati, whose son, Luigi Arconati, clearly taking advantage of his father's library, compiled from the Vincian manuscripts a book to which he gave the title Treatise on the Motion and the Measure of Water (1634). In 1637, Count Galeazzo Arconati donated to the Biblioteca Ambrosiana 11 Vincian manuscripts which are well enough described in the deed of donation to be identifiable as the Codex Atlanticus, the Codex Trivulzianus, the little Codex on the Flight of Birds, and the present Manuscripts A, B, E, G, H, I, L, and M. The number of folios of each manuscript is registered, and so we know, for example, that the Codex Trivulzianus, originally made up of 92 folios but reduced at the time of Pompeo Leoni to 55, was further cut down to 54 at the time of Arconati; today it contains only 51 folios. Arconati did not immediately hand manuscripts over to the Ambrosiana, however, because he had reserved the right to keep them with him as long as he lived; and when they were at last presented to the library, Manuscript D had taken the place of the Trivulzianus, which in 1770 was sold to Prince Trivulzio by Gaetano Caccia. Manuscript C was given by Cardinal Federigo Borromeo (p. 73) to the Biblioteca Ambrosiana in 1609 and Manuscript K was given to that library by Count Orazio Archinti in 1674.

The vicissitudes that took the folios of the precious Windsor Collection to England are not so clear. The early history of the Forster Codices is also obscure; they were in Vienna when Lord Lytton purchased them before giving them to John Forster (p. 110), who presented them to the Victoria and Albert Museum in 1876. We know that Lord Arundel (p. 111) carried out a prolonged search for Vincian papers; those at the British Museum have been put together in a rather disorderly way into the codex that is named after him. Finally, the codex that bears the name of Lord Leicester (p. 110) we know to have been purchased in Rome in the 18th century.

A further displacement was caused by the Napoleonic wars, when all the Vincian manuscripts of the Ambrosiana were gathered up in the vast seizure of works of art and precious books carried out by Napoleon. After his fall only the Codex Atlanticus returned to Milan; the others remained in Paris. It must be added that the last quires of Manuscripts A and B, torn out criminally in the 19th century by Count Libri and sold in England, became two autonomous little codices that took the name of their owner, Lord Ashburnham (p. 111), who sent them back to Paris when he learned of their illegal provenance.

The early collectors of Vincian manuscripts such as Melzi, Leoni, and Arconati used to list the manuscripts and then regroup them according to size from the largest to the smallest. Chronological classification would have been far more scientific, but its drawback becomes immediately evident when we take into account the uncertainty of many dates and the fact that Leonardo wrote in the same manuscripts, and even on the same page, at different times.⁸

Another way of classifying Leonardo's manuscripts is to distinguish between those composed with great care and those of the "miscellaneous" type. The first category consists of those that are well written and well drawn and contain homogeneous subject matter probably ready for a reader or at least elaborated to a point that only just precedes the final draft.⁹ In these, Leonardo's original intention seems evidently directed towards a homogeneous treatment, but afterwards he often adds other subjects, a date, a drawing, completely unrelated to the original theme of the volume. Only 28 of the 36 pages of the Codex on the Flight of Birds are actually related to the subject.

In the second category we put the "miscellaneous" little books whose pages receive at different times the most varied notes, sometimes in pen, sometimes in

Overleaf: Two pages from Leonardo's notebooks illustrate his powerful impulse towards graphic harmony. On page 84, a perplexing exercise in geometry creates pleasing rosette patterns in Codex Atlanticus, folio 168 recto-a. On page 85, the words, wheels, and gears of Codex Madrid I, folio 5 recto, mesh in symmetrical design. Om for monthing the second

Hand weeks

moso before brone fighter

FORTH MANY A OWNER

Contro & Ladines . Souly but 3 but 2 B (Sump)

where und o public view durates

or pum demand fem

riluma_

111

partions & climpto & Morined

154

Mereter and an an and and and

אונה ל השמאר שלאורה לי אונה ל השמאר לי אונה שלא לי אונה אונה לי אונה אונה אונה לי אונה אונ אונ אונ אונה אונה אונה אונה אונ אונה אונ אונ אונ אונ אונ אונ אונ א

netto > finalitaren ar atou german fina ten ar harrio calaritaren ar harrio calaritaren ar harrio calaritaren a harrio calaritaren harria tentare artistare calaritaren harriaren hariaren harriaren harriaren

בינייןם אילמייין איניין ו(מול אילוייין אילייין איליין אילוייין אילייין איליין אילייין אילייין איליין אילייין אילייין איליין אילייין איליין אילייין איליין איליין

if the wine pure county & 2 con pr ef: firmo mindo Support titel so sucrease during a broband of it shows no (Arvin Edimente ar Harn Die rational is proportione : elfamili forn togailfonte (sonone ellar parte arrivere en arrivere en en ellar Alla rationale Etere - Cana Parte arrivere : elle manue etermane elle antra bella va batare bat estre arrivere elle sonone : ellande antra bella va batare bat estre arrivere elle sonone : ellande antra bella va batare arrivere arrivere elle sonone : ellande arrivere bella va batare arrivere arrivere elle sonone : ellande arrivere bella va batare arrivere arrivere ella sonone : ellande arrivere bella va batare arrivere arrivere ella sonone : ellande arrivere bella va batare arrivere arrivere ella sonone : ellande arrivere bella va batare arrivere ar · Alaralino H'MAN & (A YOU mainin mai TAP MOMINY NIM ann Ammerilare alpinin An M Curlip Gurny m F. F. MAG. (um : Po MUMA) with to the illiam not of alle bon A mmunn)'r H alorn I mahan MICHAN' FANDIN wheels they india sugar mon for anne hilly with down ילוי יואי אילאי ביולי Arolo not doming amag on Pr - S THIS I IN ON AND to fin tungo ant נאסאר איותי איזא ארו איור אים איזאי אישטיי אישטיי Howney polls of Cornerrate of: che true lute mere unto lima cecus tatune atlat Mitwell truts come figmofine futhe time . A.H. ply pro . atho MART FIN WITTING cummon of Mile on minuto 4.4. WW. To be the most hours dia muiticipalot Quanto chin tila rodi in todienmo Hinnming on's comprehender wellow fonto clunoto firm open transpin no ni Brannan fit q: wa. pin. Strict R: Hoog ango under within Quilly I and wint and scan both at proverse sills merting Said migune

OUNN FOLMAGEO + 8 n PARA pid avoil a timato funn. Dip frate coli ficontro ali to Join vento (un bin bin

Loonfrequerone former 8 he 6 Low profighance adness very NUM Here of the ast in the work and

Ellento laron. n. monute file votr · r clequer cornellan gale ~ 8 n noffer Cotover bern. vt simple lower have never be nede

ONNING CONNECTION MARGINI - (M coto of the lie while de My hant amon billi rot alcontato pri to fellow did way they are me to fime actes to mette notit pit minthe Summary

Quanto mayor Alturnite to SALA WA GIANS NOT ALA AN MINO is trupolo of w full time of w cupucontra policion nation A Durind Any Lun My Very Sin very si co formation print functor motor

Onmes (croc monitorian + no pip ni mot that not by p moto tento par no by by not איי אות קופויבי נוקואתה קיקייות פיי with the for have break incore with וא א א כל ג דוריוא בירט אילא לטיירא וו - IS NAND' I AND WA NYA

KU DOPENHU CECUMODE & DAREN UN H none squale port contraction Ann alcant both calmigo And Hard in Many 1800 Mart hid atworks ? . Has will add with wells south fill no parts to I'd immusion memory of LUNGU (VOR LING IN P. CON LIN LON

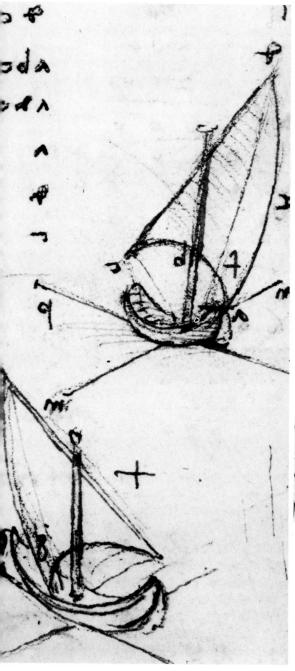

No element in the natural world so beguiled Leonardo as water and the endless beauty of its form. His notebooks abound with sketches of waves rising, unfurling, or whirling in rapid vortices. He sketched human hair and flowers in their likeness and arrived by analogy at wave theories of light and sound that foreshadowed modern physics. In his later years he even described and drew an apocalyptic vision of the world destroyed by deluge. Leonardo seldom had the opportunity to observe the oceans firsthand. In 1504 he went to Piombino, on the west coast of the Italian beninsula, to undertake a study of military fortifications. He made notes in Codex Madrid II. on the handling of sailboats, on folio 35 recto (left), and the swirling action of waves pounding upon the shore, on folio 24 recto (right). His writings often liken the earth to man's body, and water to his blood: "As man has in him a pool of blood in which the lungs rise and fall in breathing, so the body of the earth has its ocean tide which likewise rises and falls every six hours, as if the world breathed."

and severally contro and the more follow buildants sill simte defendente Wal

Through the notebooks flow countless images of flight – the caged birds that Leonardo bought, set free, and sketched lovingly, and his fantasy of man flying. The note above, from Codex Madrid II, folio 83 verso, is entitled "Of flying creatures." He inserts a sketch of a bird in the text to make his thought easier to follow. pencil or red chalk, which are often placed in the spaces left free by the previous notes. In this type of manuscript, which we can consider a "rough-book" or even "scribbling pad," we also find pages that Leonardo transcribed verbatim or summarily from the books of others for his personal study requirements. We come across both kinds of writing even in the loose leaves that Pompeo Leoni gathered together in the Codex Atlanticus: ordered, unitary, elegant pages and pages hastily sketched and without any order whatever.

The two Madrid manuscripts provide clear examples of both types of composi-

MANY WING TO I latero pare pir offering attraction to GENONMANIN CONFIL UCSI Right shaperfor unprinte change china ni & foto a filening have will fugite

tion. Madrid I, with its very elegant handwriting, splendid drawings, harmonious pagination, and complex unity of subject matter, belongs to the first category. The first 140 folios of Codex Madrid II, on the other hand, comprise a typical rough-book which is worth studying at least summarily in order to examine the intricate network of interests and problems tackled by Leonardo.¹⁰ It is certain that the notes and drawings were not written in orderly fashion one after the other, one page after the other. Occasionally, when it came to different subjects and different periods, Leonardo began his notes or drawings at different points in the manuscript, leaving frequent intervals of blank pages, which became fewer and fewer as time went on.¹¹

On July 22, 1503, "the day of the Magdalene," Leonardo started some cartographic surveys of the valley of the Arno from Florence to the sea. On the first three pages of Madrid II¹² he made some topographic sketches showing the course

of the Arno and giving the names of places and the distances represented. On other sheets¹³ the profiles of the Monte Pisano hills are beautifully outlined. Two magnificent geographic maps¹⁴ bear testimony to this activity. Intermingled with these pages, or even superimposed on them, are other notes, drawings, and arithmetical calculations, made at Piombino in the last months of 1504, that deal with the project for the fortifications requested by the lord of that city and include estimates of the costs involved in the operation.

In his early forties a new obsession overtook Leonardo - mathematics - and his notebooks began to fill up with geometrical sketches and calculations. As a painter, he long had been interested in the study of proportions, but his meeting with Luca Pacioli in Milan about 1496 seemed to have a decisive impact on his future involvement. Pacioli, one of the leading mathematicians of the day, asked Leonardo to provide the illustrations for his book De divina proportione. Leonardo studied Pacioli's Summa de arithmetica and copied from it the family tree of proportions at left. The chart includes 40 denominations distributed in a vast ramification of types and subtypes. A page from Codex Madrid II, folio 78 recto, shows that Leonardo became distracted or tired of the task and copied down only 20 of the 40 names.

To the tens of pages devoted to the fortifications of the port of Piombino must be added those inspired by the observation of the sea, which cannot have failed to arouse Leonardo's curiosity during his stay. There are observations on the motion of waves¹⁵ (p. 87); on quite a few folios can be seen drawings and notes on the direction of winds and on sailing ships and sailing (p. 86).

Although it seems as if the book was opened at random and the various

notes added here and there haphazardly, one still has the impression that in the first part of the manuscript Leonardo was following the direction of the present numeration as he wrote. This impression is strengthened by the notes that he took from the Summa de arithmetica of Pacioli - to be exact, from the treatise on proportions (p. 88). Similarly, if we move to the other end of the manuscript,¹⁶ we see that there he begins to write in a very neat hand a fair copy in the vernacular of the text of the *Elements* of Euclid.¹⁷ The transcription of Euclid's text is then interrupted, but the pages dedicated to geometry continue through almost the whole of the final section with a significant deterioration in quality: from the simple but ordered transcription of a famous text he passes to disorderly personal research into particular problems that are grouped under the title "Science of equiparation." 18 Leonardo has something of his own to say in the field of geometric studies. In the next year, 1505, he was to write Codex Forster I, which is the treatise on the transformation of plane figures and geometric solids into equivalents. He is now evidently preparing the material for that treatise, and so geometry has a predominant part in Codex Madrid II.¹⁹ The prevailing problem in this "Science of equiparation" is that of the equivalence between curvilinear and rectilinear figures, which includes the squaring of the circle. Codex Madrid II has the merit of revealing to us an elated moment in Leonardo's life: the moment at which he thought he had discovered the solution to the famous problem.

The manuscript is thus a mixture where the most various notes (not excluding two "jokes") alternate with pages copied from other books: Pacioli, Euclid, extracts from Francesco di Giorgio Martini's treatise on the construction of a fortress that are certainly connected with the works projected for Piombino. Perhaps it was prior to his departure for Piombino that Leonardo made out the lists of books and clothes that he was leaving in Florence.²⁰ The last note may be that appended on the first page of the manuscript recording the violent storm on June 6, 1505, during the work on the great painting that was to represent the Battle of Anghiari.

We have cast a glance at the literary legacy of Leonardo. We must add that the reading of Leonardo's writings presents great difficulties and can cause disappointments. Although he planned several treatises, he almost always wrote tentative notes, often a few lines, hardly ever more than a page. The same note is repeated many times in different manuscripts with slight modifications. A great many notes are not written for a reader, but are mere memoranda for his own use. Moreover, he alternates his original ideas with the transcriptions from the pages of various books. All this makes the reading of the text, its comprehension, and its relationship with other texts scattered in different manuscripts difficult for a nonspecialist. In addition, the transcriptions of his writings available today contain a certain number of errors, which are obviously reflected in the translation.²¹

Naturally, in these conditions, the persons who have read Leonardo's writings in full are few.²² And naturally, fragmentary reading has made it possible for the great legend of Leonardo as a superhuman being, the genius who embraced

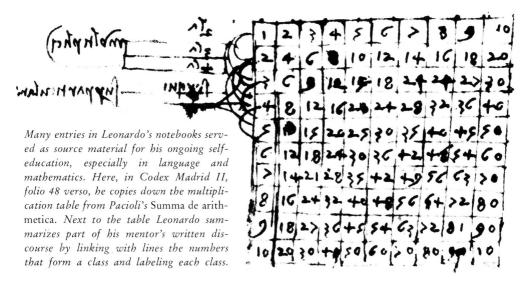

all the knowledge of his time and anticipated that of the future, to survive and grow. This legend has some truth in it, but there are several false elements that must be removed.

The fact that Leonardo's earliest manuscripts go back to the last years of the penultimate decade of the 15th century²³ means that up until about the age of 35 he had not yet decided to write books or keep a record of his ideas. Among these very early manuscripts, Manuscript B is not meant to be a treatise, but is only a miscellany devoid of literary and stylistic pretensions, containing notes on books read,²⁴ many rules, memoranda, and various observations in great disorder. But the very early Codex Trivulzianus, documents one of Leonardo's main concerns when he decided to become a writer. As Leonardo himself admitted, he was

"without letters"; that is, he had no knowledge of Latin and was unable to read and quote "the authors." He realized that his native language, the Florentine dialect and the technical jargon of the artisan *botteghe*, provided him with a terminology capable of naming all the objects of the visible and tangible world, but that it was rather poor in abstract nouns, adjectives, adverbs, and verbs that only men of letters knew or made up via Latin derivations. Leonardo sought to remedy this fundamental and primary defect by collecting words of this kind either from grammars and dictionaries²⁵ or from the very books he was reading. This took place when he was 40 years old. Later he decided to confront the study of

Ornamental variations on the letter E.

On the opposite page are samples from the Madrid Codices of Leonardo's meticulous hand. The beautifully wrought letters, the shorthand symbols that stand for syllables, even a mechanical drawing and two geometric demonstrations – all illustrate the success with which he sought to recreate the harmony and proportion he found in nature.

Latin directly.²⁶ He had all the books necessary, but there is no evidence that he was able to take full advantage of them.

The preparation he had received in the field of mathematical sciences in his youth was also very inadequate. He was never very good at calculation, and even in terms of the knowledge of concepts the gaps in his education were far from insignificant. For a while he shared the doubt of many inexperienced persons as to the validity of some basic rules.²⁷

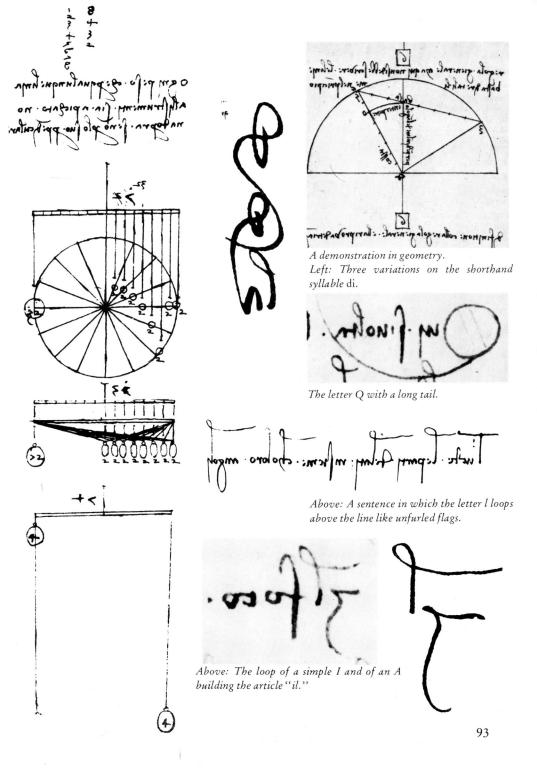

Pacioli (p. 95) claims to have been Leonardo's colleague in the pay of Lodovico il Moro from 1496 to 1499 and to have been his companion in the following years. He further states that in 1498 Leonardo had written or was writing some books and had sketched the "wonderful drawings for the five regular bodies." To carry out such a task, Leonardo must have been acquainted with the problems involved in the construction of regular polygons and in general with the theory of proportions. It is significant that from 1496 on Leonardo's manuscripts devote more space to geometry. Manuscripts M and I, datable between 1496 and 1499, dedicate a hundred pages to the study of the very first books and some parts of Book X of Euclid's *Elements*, something that was almost certainly conditioned by the mere presence of Pacioli and by Leonardo's commitment to illustrate De divina proportione (pp. 98-99). The notes of Manuscripts M and I have a particular form; Leonardo never transcribes anywhere from the Latin text, which nevertheless he has at hand, but just traces some geometric figures, often adding in the upper margin or beside the drawing the number of the corresponding Euclidean proposition, or even a few words representing a fragment of the discourse which is taking place in his mind. This shows us clearly that he is writing only for himself. Since in Manuscript I we also find notes that Leonardo made for an elementary study of Latin, we ask ourselves how he was able to read and understand the difficult Latin of Campano, who translated and wrote a commentary on Euclid. That Leonardo is using the Campano Latin edition is confirmed by the exact correspondence of the drawings and by the occasional tell-tale Latin word, such as conclusio or propositum.²⁸ The presence of an expert would have been indispensable in overcoming the linguistic barrier, and it seems likely that it was his friend, inspirer, and master, Luca Pacioli. The latter must have made a précis for him of the Euclidean page, which he condensed in a few lines. In the first two parts of Manuscript K, of 1504, many pages are given over to the study of other books of the *Elements*, and a group of folios of the Codex Atlanticus (pp. 96-97) seems to be intended as a résumé of them in a more organic and complete form.29

We thus reach the very important conclusion that only between 1496 and 1504 did Leonardo come to know and study Euclid's book; in other words, at the age of 50 or thereabouts Leonardo was still a student as far as Latin and mathematics were concerned.

While there is no proof that he continued to study Latin, geometry became a real passion for the rest of his life. He worked intensely on the problem of the duplication of the cube, trying out various solutions which were clearly absurd. In Madrid II³⁰ appears a drawing, unaccompanied by a text, of the solution given by the ancients and referred to by Giorgio Valla.³¹ Leonardo severely criticized several times this old solution until he succeeded in perfecting it by means of a little but authentic discovery,³² which has passed unnoticed until today, and of which he declared himself to be very proud.

He is not so justified in his pride at having surpassed Archimedes in the problem of the quadrature of the circle. The solution which came to him in a flash on St. Andrew's night, 1504, consists of comparing two circles whose areas are in the ratio 1:1,000,000. The smaller circle is therefore equivalent to a sector of the larger circle and equal to one-millionth of it. Such a sector

The Franciscan monk and mathematician Luca Pacioli (on the left) not only influenced Leonardo's interest in geometry and proportions but was the first man of letters to proclaim him publicly as a writer. In his introduction to De divina proportione, for which Leonardo drew the illustrations, Pacioli praises both these drawings and "a worthy book on painting and human movements" – a work since lost.

would practically be equal to a triangle, as the arc which closes it, being very short, would be – says Leonardo – "almost flat." In other words, whereas Archimedes divided the circumference into 96 parts, Leonardo divides it into a million parts, as if constructing a polygon with a million sides. However, while Archimedes by his demonstration arrived at the ratio 22:7, very useful for the actual measuring of the circle, Leonardo goes no further than to affirm the equivalence of a circle to a sector of another circle, without calculating any measure. According to Leonardo, Archimedes' quadrature was "well said and badly presented," but his own is only described and not presented at all.

It is clear that after studying Euclid and Archimedes for roughly eight years Leonardo follows his own direction. In 1505 he composes Codex Forster I, which is dedicated to the transformation of one area into another or one solid into another equivalent one; and he fills up part of Codex Madrid II

and hundreds of folios of the Codex Atlanticus (pp. 100–101, 105–107) with studies of the transformation of curvilinear surfaces into an equal number of rectilinear ones. The first are triangles with three curved sides or "falcates" with one or two curved sides; they are circular segments, or "portions," which lie between the sides of a polygon inscribed in a circle and the circle's circumference. Several times he shows the intention of putting together the conclusions of his studies into one or more treatises, for which he proposes the titles: "The Science of Equiparation," "Book on Equation," and "Geometric Play."³³ The results, when considered from a strictly scientific point of view, are not significant, but it cannot be thought that Leonardo dedicated so much time in the last 15 years of his life to a banal work.

To the end, the figures to which he comes back most often are curvilinear stars

inscribed in a circle, often forming complex and harmonious drawings. The construction of these figures is regulated by a constant mathematical norm, which serves to "vary ad infinitum" one or more surfaces but at the same time maintain the same quantity.³⁴ The principle of proportion dominated Vincian thought. In the study of Pacioli or Euclid the theory of proportions always had an important place. Now Leonardo delights in constructing infinite geometric "equations," deriving the same pleasure that a mathematician gets from developing algebraic equations. Let us imagine a square inscribed in a circle. The straight sides of the four circular segments, or "portions," that remain outside the square are then

Another major source of Leonardo's education in mathematics and geometry was the Elements of Euclid. The notebooks show a decade of study and speculation that cover virtually all of Euclidean geometry (left).

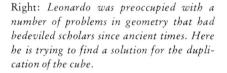

joined up in twos. They will form two "double angles" with curved sides (Leonardo calls them *bisangoli*), similar to olive leaves, which can be placed inside the circle dividing its area into two parts: one situated between the circle's circumference and the contours of the two *bisangoli* which is no longer a square but is still equivalent to it, and the other comprising the two "leaves" which correspond to the four original segments.

He sees in the structure of the natural world the sovereignty of "Necessity, bridle and eternal rule" which is of a mathematical nature and subjects everything to the law of proportion.

What does nature do if not vary infinitely its forms with a limited and unchangeable quantity of material? Playing with the mathematical laws of proportion

Leonardo's illustrations for De divina proportione – complex three-dimensional designs in solid geometry – were extolled by Pacioli as "extraordinary and most beautiful figures." Among the drawings were the socalled "Platonic regular bodies;" five polyhedra that Plato had said defined the forms of the five natural elements: the pyramid – fire; the cube – earth; the 8-sided octahedron – air; the 20-sided icosahedron – water; the 12-sided dodecahedron – heaven. Leonardo drew these in all of their variants; he already had been exposed to the geometry of perspective in his early days in Florence,

and the abstract perfection of these intricate forms must have pleased and intrigued him. In 1501 he was so obsessed with mathematics that he neglected his painting and, writes an observer, "the sight of a brush puts him out of temper." A new interest, however, always took him back to old familiar ones, enriching his painting and helping him penetrate engineering theory and practice. In Manuscript K he writes, "Let proportion be found not only in numbers and measures, but also in sounds, weights, times, and positions, and whatever force there is."

and proportionality Leonardo practices infinite variations on the forms of a quantitatively unchangeable area. This is the meaning of the title *Book of Equation;* even the inexhaustible forms of nature are only the infinite variations of a basic equation. This is form seen as function, one of the conquests of Renaissance science; and to its realization the artists and those who studied natural philosophy, the inventors of perspective and the experimenter-engineers, Luca Pacioli and Leonardo, all contributed. It is the final result of geometric research begun with the collaboration of the two on the treatise on divine proportion, research pursued for many years by the artist Leonardo alone

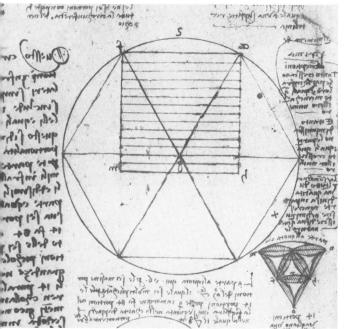

In the drawing at left Leonardo demonstrates how to subdivide a part of a circle into 14 equal segments. With one of the sides of a hexagon, inscribed in a circle, he constructs a square and then divides it into 14 rectangles. Leonardo continues his demonstration by indicating that one of these rectangles is now transformed into a square into which in turn a circle is inscribed and inside it another hexagon. This new circle. the hexagon, and the portions made from it are now in the ratio 1:14 to the original circle, its hexagon, and the corresponding portions.

On the right Leonardo recommends avoiding a subdivision into an odd number of proportional parts.

with limited means and concluded, not with the definition of a scientific law, but with a series of illustrations showing it applied.

This new vision of the activity of Leonardo in the study of Latin and the mathematical sciences makes it easier to answer certain questions which in the past have aroused considerable perplexity. Was Leonardo an artist or a scientist? Did he discover experimental method? Did he really create Italian scientific prose?

Leonardo was certainly a great artist, and the artists of the Renaissance made a great contribution to science. With the discovery of perspective, with the conception of space divided and unified by the geometric projections of rays of light, with the use of the drawing as the perfect instrument for scientific demonstrations, with the conception of art and of beauty as mathematical proportion and harmonious unity of the parts, scientific thought took a new direction. It was a decisive turning point. Artists were not completely isolated from the official world of science. Between the masters of the liberal arts and those of the mechanical arts, between abstract thought and the practical applications

in the world of manual work, there was no lack of contact. Toscanelli and Manetti influenced Brunelleschi, Alberti combined the double experience of literary and artisan activities; Leonardo and Luca Pacioli worked together for many years, and as we have seen, the intervention of Master Luca was decisive. Nevertheless there existed between the two categories a social and hierarchical conflict, even if no one had ever placed in doubt the supremacy of the liberal arts as the only depositories of true science. And the one who rose up resolutely against the exclusion of the mechanical arts from the sphere of science, or as it was then known, "philosophy," was Leonardo.

allemme a fogano afegniare Afentiro affarlin afuefar: a fummar: afunto ANituita appilo afiatica aNiterar:

This list of Italian words, taken from the page reproduced at right, was part of Leonardo's course in self-improvement. Lists of the same sort – abstract nouns, adjectives, and verbs known to scholars but not ordinary people – fill 54 pages in the earlier Codex Trivulzianus. He began collecting such words from grammars, dictionaries, and other books when he was about 40, labeling them vocabuli Latini because they sounded like Latin. Later he decided to study Latin itself.

In the pages of Codex Madrid I, Leonardo's concern for proportion and harmony keeps breaking through and transforming ordinary blocks of words into works of intricate visual beauty. Here, to emphasize the extraordinary graphic qualities, folio I verso is reproduced at right, and rendered schematically above. In the schematic, Leonardo's potpourri of mundane jottings takes on an abstract and subtle harmony suggestive of a painting by Mondrian. The contents of the

page seem random. The top line announces the date, New Year's Day 1493. Below it are three blocks of writing. The first muses on the problem of making a perfectly round large circle; the two others, each with a oneline title, relate to the use of geared wheels. The tall block of writing at the lower left of the page is one of those items of practical advice that pepper the notebooks – this one tells how "to make burnished iron appear as if it were painted with blue spots."

at primo newnaso. 1+92.

of h. orof : mor of our no vinite) : Bad with by leants a sedwed a li leantes And we change in orloand it is to

Ac from hills took

Arrow he gorth : fin

totto frome urbourol served served served and a server server served served served served and a served served a served served served served a serve

a former a figane afegujara Afintito a Marlin a fuefar: a fumman. afunto apiquita appilo afiatica aNiferar:

When the rest in the second of the second of the second se to the two profiles betterno - bunne « The state of a new regarding and a service of the who sorden withere but lither mu & when divite a bos when the when איני לעימה ארידוי זה הבעירה בי ניסו דו ד ANTA D: VRUCALENE VERNERA CE HPOINCEIN CHA. MOMA CABITO CATELIA b) (near som ella for for the there & por Subidual & giver under famme elle for min fate araro quelo della mace elle When haters & and - 2 th you with for acito (ipartita crimaria, ifpris promise courses times defer anta some builty sived summers . atmine to anot Deader Con foll a posto teres and the former were associated a star Having inscribed a section of a hexagon in a circle, Leonardo wants to divide the portions outside the hexagon into a certain number of submultiple portions. He recommends that such a number always be a multiple of 6. Therefore he makes a table with two columns (sketched horizontally): one of them with the numbers from 1 to 50 (which we would call the "independent variable," or x), the other with the corresponding multiples of 6 (the "dependent variable," or y), hence it is clear that y is a function of x. AC CON FURT SOM

בלי כו מולכת לי הי כשיים

10 cial curve dege no a funale les all To Ist any mereliant is 150 . 44 graphing matrices and here is an a squark and balan fillions

Overleaf: The abstract game of squaring portions of a circle comes to life under Leonardo's pen in rows of crescents, paired leaves, pinwheels, and rosettes.

a bale be fut a vale bet all a vale bet e all a vale b co al a vale b co ba a la vale b color a la vale be color a la color all a vale bet all a vale bet a vale b Unit ides & startin - Her windigen ר הנהלראמה (חשוסדני ו הידה שה ניאים מלורע HAMAN FOILMAN ~ using (earlier a parte de al a parte de ante a parte be aprese (and a party & ball & all a ball a property of יוני הקוניולים לושה הוני הקוניולים למוח שיוני הקוניולים להיום און קטעאראר ציור בסלימערקטעביי ול אס (אם בן פינקאופויו און קטעאראר ציור מהכאונים ספאליב פט ולעארקאים אין נפן portions builts when builtede de for carts have POPPIONE DACOMA DUMME IN C - + IN D pe palete f abe vale te f a vale b straftal a vale be f 10 abe vale be a vale be o 10 a o a vale be o 10 a o ale and the hostion in the week of the hosting of the prove of the provident of the week of the prove of the prov - 2. . A Mund o unit stand mund in the nofenper 1 MA HAVIS MART High rate and ap inde con ap pale contrate (and the future and contrate un) a pale and copy ap nat יוונגילועי להלימון חוד על אירועין איר ישראל איר איר אירועיל איר אירועין אירועין אירועין אירוגילאוו כיר אין איר עונגילועי להלימון מענט געון לאיר איר אירועין אירי אירועין איר אירועין איר אירועין איר געוני אירוגילאוו כיר איר א עונגילועי להלימון איר אירועין איר אירועין אירי אירועין אירועין אירועין איר אירועין אירוגילאוו כיר אי A normal b 2 to be the set of the proceeding out of the boo pola & on the set ber and a polarising and a polarising the set of a left be to a polaris and a polaris a polaris and a polaris and a polaris a po UNP-M-INC an tod stad Mert Cime mane to be C hi for unmalp parano A MARTINE MAL. P. 1 Summer A 34. and made

Perhaps the very idea of writing a treatise on painting was born out of a dispute with men of letters and philosophers over the supremacy of the arts. By placing the polemical discussion of Leonardo on the supremacy of painting at the beginning of the Treatise, Francesco Melzi shows that he understood that this was really a beginning and a revolutionary turning point. The first objective of Leonardo's polemic is poetry, the literature that he places under accusation. By accusing he defends himself, because he admits his deficiencies. The painter is a man "without letters" who does not possess to the full the contemporary linguistic instruments, knows that "he cannot express himself well," and so is unable to read and quote the great books of humanity. But the painter reads and studies every day the divine book of nature, interpreting and reproducing directly the words of the supreme master and author without having recourse to other interpreters. No poet can surpass the painter in representing the "works of nature" and the "beauty of the whole world." The poet may surpass the painter in the capacity to reproduce human discourse. But "how much more difficult it is to understand the works of nature than the book of a poet!"35

The second objective is music. This is considered a mental science and therefore included in the nonmechanical, or liberal, arts, because it is founded on the numbers of harmonic proportions. But painting too is a mental science, because just as "music and geometry consider the proportions of continuous quantities and arithmetic those of discontinuous quantities," painting "considers all the continuous qualities and the qualities of the proportions of shade and light in its perspective."³⁶ The redemption of painting and its transformation into a mental science became possible thanks to the invention of perspective, which introduced number into the artist's technique.

All this is not enough to define the excellence of painting. The life of men and things is not fixed in the synchronous unity of immobile space; it flows on in the river of time, continually varying the lines, the surfaces, and the forms of things. Herein could be found the weak point of painting, "which encompasses the surface, colors and forms," while "philosophy penetrates within those same bodies, examining their properties." ³⁷ So the painter's perspective "spreads in the increasing and decreasing of bodies and their colors. . . . Therefore painting is philosophy." But Leonardo feels that the pyramids of the rays of light in which the painter arranges the objects, graduating their dimensions in proportion to their distance, have a character of rigid immobility; they At the beginning of the Treatise on Painting – as Francesco Melzi later arranged it – Leonardo argues at great length the supremacy of painting over the other arts. He takes on poetry first and tells the following story: Leonardo's tale of King Matthias may have been based on an actual occurrence. King Matthias of Hungary was known as a great patron of the arts. He got on well with Lodovico Sforza, and there is evidence that Sforza asked Leonardo to paint a picture of the Madonna for the king.

"On King Matthias's birthday a poet brought him a poem composed in praise of the event which he said was for the benefit of the world, and a painter presented him with a portrait of his beloved. The king quickly closed the book

of the poet and turning to the picture fixed his eyes on it with great admiration. Then the poet very indignantly said, 'Oh king, read, but read, and you will learn matter of far weightier substance than a mute picture.' Then the king, resenting the reproach that he was admiring mute things, said, 'Silence, oh poet, you do not know what you are saying; this picture serves a nobler sense than your work which might be for the blind. Give me something that I can see and touch and not only hear, and I do not blame my choice when I put your book under my arm and am holding the painting with both hands for my eyes to enjoy; because my hands chose of their own accord to serve the nobler sense and not the sense of hearing.'"

envelop the bodies from the outside, while science penetrates into them in order to discover their internal properties. Life flows in them like a wave and from their heart irradiates the heat of internal energy. Ficino, of whose teaching Leonardo had received at least an echo during the youthful period of his Florentine formation, had criticized the definition of beauty as harmony or proportion of parts and had defined it as "vividness of action and a certain agreeable quality shining brightly in movement itself." Leonardo has this in mind when, using Ficino's words, he "proves that painting is a philosophy because it deals with the movements of the bodies in the *vividness of their actions.*"³⁸ A careful observation of many of Leonardo's paintings and drawings

John Forster.

A large number of Leonardo's manuscripts and drawings now reside in England, though the precise routes by which they reached there are murky. In the 19th century the three Forster Codices – two of them small pocket notebooks – were purchased in Vienna by Lord Lytton. He

gave them to John Forster, who in turn donated them to the Victoria and Albert Museum. Sometime between 1713 and 1717, Thomas Coke, later Lord Leicester, purchased from a painter in Rome the codex named after him, which deals only with the subject of water. In the 19th century, the

will enable us to discover that their beauty is a "certain agreeable quality shining brightly in movement itself."

Leonardo combines the legacy of the inventors of perspective, of those who favored light as the principle of vision and then of knowledge, and that of the investigators of the "spiritual virtues" (that is, the physical energies inherent in the world – heat, force, gravity) as the principle of movement and of life. For him space is not a simple receptacle, but a field traveled over by visible and invisible forces; surfaces do not merely reflect light, but betray the internal tensions of sensitive and insensitive beings. Before reading Euclid Leonardo had studied De

Lord Ashburnham.

fourth Lord Ashburnham gave his name to two codices that actually had been torn out of Manuscripts A and B by Count Guglielmo Libri. Libri brazenly sold the illgotten manuscripts to Ashburnham, who later returned them to Paris. The most successful English collector was Lord Arundel,

a 17th-century seeker of Vinciana. He owned the codex that bears his name and most likely was responsible for taking to England the big collection of drawings now at Windsor Castle. The evidence also indicates that he tried unsuccessfully to obtain one of the Madrid Codices.

ponderibus, where it is stated that a heavy body "desires to be under what is light, and what is light to rest above what is heavy." From there derives a jargon dear to Leonardo in which "every body *desires* to fall," "force always *desires* to become weak and use itself up," and "when the weight comes to a halt there it *rests*."

Leonardo goes further than to place painting as a mental science in the sphere of liberal arts. His polemic broadens so far as to deny traditional science a real validity and to propose a new kind of science. The opposition between the poetry of the men of letters and the painting of the men without letters ends by dividing science into two distinct fields: "poetry extends into moral philosophy" and "painting into natural philosophy"; 39 "literature represents with greater truth the words," "painting represents for the senses the works of nature with greater truth and certainty."⁴⁰ There is thus opposition between moral philosophy and natural philosophy, divided by diverse methodology. The painter who comes out of the schools of mechanical arts possesses the method of practical experience which checks the validity of the rules imparted. Moral philosophy "begins and ends in the mind," but "in such mental discourses experience is absent and without this, there is no certainty."41 On the other hand, experience alone is not sufficient. "No certainty exists where none of the mathematical sciences can be applied."42 Only the mathematical sciences with their geometric demonstrations and numerical calculus make it possible to frame experience in a mental discourse which forms real science, or rather the new science as conceived by Leonardo. This leaves to the men of letters the study of metaphysical problems and the essence of things, very noble objects but unattainable by experience and consequently the source of interminable disputes. "Where there is shouting, true science is not to be found, because truth has only one term, and once this is made public, controversy is destroyed once and for all."43 Forced to give up a source of certainty like experimental examination, the traditional philosophers take refuge in the authority of the ancients and often are reduced to repeating their words without adding anything of their own - mouth-pieces and reciters of the works of others.44 Leonardo rejects the principle of authority, gives up metaphysical problems, announces the birth of a new science born of the union of mathematics and experimental activity. Even if he does not succeed in formulating with precision and applying the correct rules of the experimental method, he has clearly realized and affirmed that science could not progress without taking over the method of the mechanical arts which were looked down upon. Manual work, once reserved for slaves, and direct contact with the material, considered an obstacle to the purity of ideal contemplation, are now fully redeemed as necessary elements for the attainment of scientific truth.

From what has been said it clearly appears that Leonardo cannot be compared with the traditional types of scientist and writer and that it is useless to ask whether he was more an artist or more a scientist, and whether he founded Italian scientific prose. The very famous notion of his universality must also be freshly defined within precise limits. The artists of the 15th century were scientists as well, up to a point, but no one was more conscious than Leonardo of the revolutionary character of the contribution made by the pupils of the artisan *botteghe* to the progress of science. And even if Ghiberti had written his modest *Commentaries*, if Francesco di Giorgio Martini, Piero della Francesca, and above all Leon Battista Alberti had composed various detailed treatises on perspective, painting, architecture, and other subjects, Leonardo, although having an inferior literary and scientific preparation to that of Piero and of Leon Battista, imagined a much vaster treatment that included – in addition to painting – mechanics, engineering, anatomy, and hydraulics and touched on problems of geology, cosmology, astronomy (the greatness of the sun and the distance of the stars), and botany. It does not matter if the means of solving these problems were not always adequate and the results not always happy; what does matter is that Leonardo wanted to create a rational theory for all the practical activities of engineers and proposed with great certainty a new vision of scientific progress, liberated from the authority of the past, that would search for the criteria of truth and certainty only with proper logical coherence and with experimental proof.

From the literary and stylistic point of view, too, Leonardo's writings present varying degrees of care, depending on the particular moment at which they were drawn up. But they all have one common characteristic. In spite of Leonardo's impressive affirmations about the many books projected by him and the titles he placed at the top of various pages, we are unable to trace even a partial draft of any book whatsoever that is organically continued over a substantial number of pages.

The artisan environment in which he received his early formation certainly influenced his literary style. It was an environment that expressed itself not by means of organic and complete treatments of problems, but by series of rules, more or less fragmentary formulas, and directly by means of the manual operation, which dismisses words and provides an immediate and clear demonstration.

Rarely does Leonardo's discourse cover more than a page and very often a single page contains many propositions, made at different times, of different or analogous subject matter but always clearly separated from one another. The art of elaborating a question in a dense texture of inductions and logical deduction until it becomes an architectural development is unknown to Leonardo. Neither is he capable of passing gradually from one thought to another, gathering together a vast complex of considerations and at the same time pleasantly entertaining the reader. His style is certain, decisive, and sometimes aggressive. month forthe formatic hape month

felly eders mirety le telle o But, allor speff oreine forthy wetter er there (any (- out Gen " finin entiper disper en emofime inch if le le pores lor opposing Berte feline Tomo et undo Aprican falty Sale finds the fiture ride fipold Inches * alityung tipofy lung Ad offitige fi premo fotutto softe efem alte since from Seite legunt almitte sellion numeral magene fiere Gration ane for los no formen eramenener frotanelle lorente leprime momette provegie emote alter fimily Diroth inelli bevery melte oper & have to industrice leginal fiction to efth etwarth fo ce fipefferne

eachy inche tore more me to erer est At Atomary emotione Aprilagelo une fimme dour toment p experiencelte Brent Potro lyennish cente mer coffer lensuels fits eports i bus moon for TIPATENER I quelle . In de fine in delle informe del fimme vorante à groff sport pal of one ale male for undino bisweft Comercine f Se finne bone to 12 Apto moveme Sure Augte esul werneverne fate Trette form to beffe (the of allo com va ne haffens So poffer fintherne mello Sufatiever Trivil . naliponte Bapero fime Boling showto mure decufictant (the And e entrole Sewer a lamoremon Someres & fur permite fiberete de curocuolis notes encine a buffe for lufter perfrance tile lande some nos pafferdeure in paffarm molonente morecenne linterfy: bue tatuefe ale inelle Acconsto Delfume infeliment Se denour , Bing ale fronte deffe are shall remalie nelle fire stame po Lord Ashburnham also took back to England a treatise written by Francesco di Giorgio Martini but enhanced by marginal notes in Leonardo's hand. On the page reproduced at left Leonardo sketched a fierce wave and noted:

The wave of the sea bursts open and crashes before its base and that part of the crest will be lowest which formerly was highest.

Francesco's treatise was one of the most important early Renaissance works on civil and military architecture. In his own notebooks Leonardo borrowed freely from the book by his older contemporary. Such a treatise also may have inspired Leonardo to arrange his own writings in more systematic form, as in Codex Madrid I. The fragmentary character is therefore a constant feature of Leonardo's writings. It corresponds to his habit of rapidly committing to paper an unexpected idea, a simple memorandum, a temporary note to be taken up and developed later. He concentrates for a short time only on his effort to achieve good expression. The world of artist-engineers is accustomed to expressing itself more by means of the drawing and practical demonstration than by means of ample discourses. For Leonardo the drawing is a scientific and demonstrative instrument far superior to the word. "O writer, what letters will you use to write the whole figuration with such perfection as the drawing achieves here?"⁴⁵ This is not valid for all the sciences, but it strongly influenced the general arrangement of ideas throughout all Leonardo's work, where figurative discourse alternates with oral discourse. The subordination and underestimation of the latter is one of the main causes of the fragmentation of this thought into thousands of disconnected and unrelated notes.

But this is not enough to suffocate the fascination of Leonardo's writing: a beauty that cannot emerge evenly from all the notes he made in his manuscripts in circumstances greatly varying from one to the next; a splendor that can only shine briefly in a word, in a sentence, or in the space of a few lines, and yet leaves a profound impression on the reader: "Sea, universal lowness and sole resting-place of the roaming waters of the rivers."⁴⁶

The famous description of the Flood in Windsor 12665 is a page where the dramatic details that the painter must gather together into the grandiose representation of the universal cataclysm are amassed in disorderly fashion. There is an evident contrast between the profound unitary sentiment (that would be fully expressed only in the real pictorial representation) and the desultory general texture of the narration. It therefore arouses no wonder that from a stylistic point of view the summary of this description, placed by Leonardo under the title "Divisions" and almost reduced to a mere list of words, appears as freed from rhetorical encumbrances, from tiring grammatical connections, from every attempt to achieve a careful architectural construction, and relies solely upon the rhythm of a genuine interior scansion: "Darkness, wind, sea-storm, bolts from heaven, earthquakes and ruin of mountains, leveling of cities...."

In this changeable musical rhythm that binds and exalts Leonardo's phrasing in its better moments we can recognize the lyrical component of his temperament. Although his phrasing tends through habit towards a linear and concise development, the scheme of which can be abstractly illustrated in a sequence of rectilinear and almost equal segments, there are moments when such segments tend to overlap one another as if bound together by reverberations of rhythm and of sound into stanzas: "If the loved thing is vile, the lover becomes vile. . . . When the lover is joined to the loved thing, there he rests. – When the weight reaches the ground, there it rests." Here the breaking up of the grammatical texture is only apparent, as the brevity of the phrases represents only the concentration of an energy that links them all together in a single rhythm; it is a means by which truth is announced and stressed intensely, solemnly.

But there is a great variety of rhythms, from a gentle, timorous, and light flow – as in "Pay attention to the faces of the men and women in the streets as evening falls, when the weather is bad. What grace and gentleness they reveal!" – to the violent and flashing rhythm of these definitions of force: "It lives by violence and dies by freedom." "It transforms every body and obliges it to change situation and shape." "Great power gives it the desire of death." "With fury it drives away anything that obstructs its path of destruction." In these extracts the exact scientific thought is not well formulated; rather it is replaced by the contemplation of images and operations that constitute the concrete effects of a scientific principle not yet clearly specified. This means that at these moments the poet, the artist, the wonderstruck spectator of the amazing effects of nature prevails over the man of science.

It is no easy matter to find beautiful passages in Codex Madrid II, where care as to form is very rare. Neither does Codex Madrid I distinguish itself from a literary standpoint by special stylistic merits. The writing is more careful than usual, and the haste that characterizes other manuscripts is not present, but the subjects are very technical: the description of devices and parts of machines, from which only a few notes deviate. The flyleaf had been used up for some outbursts, such as the one against the seeker after perpetual motion, and some confidences, such as the doubt that seems to torment Leonardo concerning the realization of the great equestrian statue dedicated to Francesco Sforza. The creation of a great bronze horse could, in the event of a war, arouse the cupidity of the enemies, who would take it away to their own cities. Rome in fact was full of grand monuments plundered from conquered cities. If he were to make it in marble with dimensions and weight so great as to render it untransportable, it would be destroyed to make "walls and mortar." The point is, however, that destiny is inevitable. "Do as you will, everything has its death." This sounds like a foreboding of the end of his masterpiece, destroyed by enemy soldiers not through cupidity or for utility,

ANNOVAGINIS: A NHOD

o begino grano e fagono pravne itana dious securito edisave libolle i duris ungrature by unamines . Ending tool company colly Jungmon propo lochoone .. bouche to the (unduencial lobu (u surve) in: cicoli una cosu 1 manust grile mader: duebe tions effore equals almagons corregio "unoan sharaft GANS "undut whome

Leonardo came to attach such great importance to mathematics that solving a problem would be the occasion for a special entry in his notebooks. He dramatically announced in the margin of folio 112 recto in Codex Madrid II the following event of November 30, 1504:

The night of St. Andrew, I finally found the quadrature of the circle; and as the light of the candle and the night and the paper on which I was writing were coming to an end, it was completed; at the end of the hour.

He thought he had surpassed Archimedes, who 17 centuries before had established the ratio of the circumference of a circle to its diameter as 22:7 and thus permitted calculation of the circle's area. Where Archimedes had divided the circumference into 96 parts, Leonardo attempted to divide it into a million parts. He compared two circles, one a million times larger than the other, and assumed he had squared the circle. But he did not actually calculate a measure, and his moment of elation turned out to be a delusion.

but as a game, thus rendering vain even the last doubt that closes the extract: is it fair that the work of art brings more honor to the artist than to the person who commissions it? It is normal, replies Leonardo, but the glory of his horse could be appreciated neither by posterity nor by his contemporaries.

Another parenthesis of great interest is the following declaration addressed by Leonardo to the reader: "Peruse me O reader, if you find delight in my work, since this profession very seldom returns to this world, and the perseverance to pursue it and to invent such things anew is found in few people. And come men, to see the wonders which may be discovered in nature by such studies."⁴⁷ It is unlikely that these words refer directly to the astronomical drawing that is beneath them, but they certainly have to do with the study of nature and its laws that Leonardo had been pursuing for so many years in so many different fields.

Now compare this page with that very well-known one⁴⁸ on which Leonardo modestly compares himself to "the man who arrives last at the fair because of his poverty" with "merchandise that is looked down upon and rejected" as not of "great usefulness and pleasure," and note the reversal of the situation. The profession practiced by Leonardo has appeared only on very rare occasions in the world, as it demands a patience reserved to few, but it is the cause of great pleasure, because it reveals to men the wonders of nature. Nature is the center of Leonardo's basic interests, the spectacle he examines with unexhausted wonder. Against those who look down on the study of natural phenomena and prefer the description of "miracles and . . . those things that the human mind is not capable of demonstrating and that cannot be demonstrated by any human example,"49 Leonardo, with a radical inversion, sets another type of miracle, that of which "the mathematical sciences" succeed in giving a rational explanation. This miracle gives rise to amazement, but an amazement produced by the discovery of the reason infused in things - that is, by the dissolution of the mystery that enshrouds them.

This is a delicate point. The rationality that constitutes the intimate structure of the universe is a law, which Leonardo calls "Necessity," restraint, a rein imposed by God upon the free expansion of the cosmic energies. On the essence of these energies that animate the world nothing can be said; science, which shuns metaphysical discourses, devotes itself only to their effects, that is, the rhythms and the formalities of their operations. The true miracle, which can be known and admired as the revelation of an immeasurable wisdom, is the law, or necessity, to which the elements of matter and the forces that move them are subjected. Herein lies the metaphysical residue that Leonardo does not want to investigate; he is satisfied with the spectacle offered to his

Leonardo's writings reveal the solitary meditations of the artist and scientist, but they also suggest the image of a man who liked to entertain and amuse his friends. His notebooks are spiced with jokes he has just heard, fables about mythical creatures, and riddles that Leonardo called "prophecies." These riddles describe everyday occurrences but are worded in such a way as to sound like the apocalyptic visions he would later draw. One example: "Much of the sea will escape toward the sky and will not come back for a long time." The answer is the normal evaporation of water into clouds. At the Sforza court in Milan Leonardo apparently was something of a social lion, singing, improvising verses, playing practical jokes. He made up pictographs, like the ones shown here (the Windsor Collection 12692 recto and verso) which combine pictures and words to create a sentence or phrase. In the center of the detail above he writes, M'asomiglio ala (I look like the) and adds a sketch of an ant.

Cogli acierbi With the bitter ones

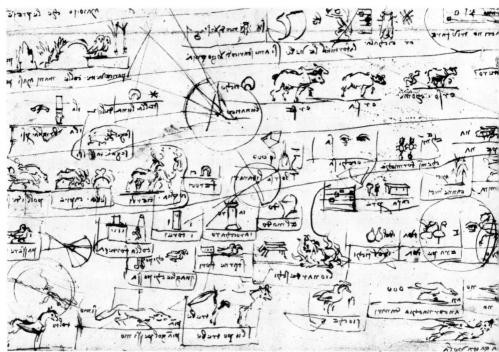

Lionardeschi Leonardesque

eyes and with the harmonious motions whose rhythms and mathematical proportions his mind measures; but it cannot be denied that Leonardo's soul is stirred by this metaphysical residue that is preserved from intellectual investigation. We only have to remember the splendid definitions of force already cited, where the changeable behaviors of an energy are felt and presented as an invisible, mighty, individualized protagonist. Of this eternal and unchangeable substance the only knowledge, the only discourse conceded to man, consists of the description of its effects, of the definitions of its functions. Here too – as said earlier about Leonardo's geometry – we are witnessing the shift of the focal point of scientific discourse: from the substance to the function.

Po[n] l'occhio. Be careful. More of Leonardo's visual puns are shown here, with four examples enlarged and translated. These pictographs were probably intended as a kind of dictionary of illustrated fragments from which he could compose picture puzzles for his friends and patrons.

Even the concept that Leonardo has of beauty feels the effect of these two poles of his thought: beauty is rationality, harmony of mathematical proportions, but it is also, as Ficino said, "vividness of the actions," the manifestation of a vital impetus, and therefore the revelation of a substance or invisible essence. The passing from medieval to Renaissance concepts thus takes place gradually, without violent contrasts. The rationality and the beauty of the universe are the stamp of the divine mind in the world. God is still thought of as creator - though called author and master - in the sense that this word had in the artisan botteghe: the artist who imagines the form and causes it to materialize. The world is the masterpiece of the supreme artist. The study of nature leads to the revelation of the divine mind; the imitation of nature confers on the mind of the painter the creative character of the divine mind. Here we can discover the unifying center of all Leonardo's activities. He studies nature like a pupil who wants to discover the secrets of the master so as to compete with him in inventing and painting pictures that pulsate with life, in making machines and devices that make inert material seem to come alive.

Però se la Fortuna mi fa felice, tal viso asponerò. Thus if Fortune makes me happy, I will show such a face.

MITH-CAREL ESS

Felice sarei, se dell'amore ch'i'ti porto restaorata fossi. I should be happy, if my love for you were reciprocated.

Però tribolo, onde . . . But I suffer, therefore . . .

In the sheet of pictographs on the opposite page, Leonardo sketched an unrelated plan for a palace in the lower left portion. The palace may have been the Corte Vecchia, where he lived in Milan. "...It is my intention first to cite experience, then to demonstrate through reasoning why experience must operate in a given way."

THE WORDS OF LEONARDO

ANNA MARIA BRIZIO

124

number . Hurt. - 2 . HIM MANNANON: Bed : Wand in . all a low is us us a low with a low pio . S. A. Doce . Dmana 'c Ci colmanit: tamano IN : giv com: Allamo Satorta : wulling weight of a cla i wood of i = int HA WAND WANT

This sketch apparently was inspired by Leonardo's profound knowledge of anatomy. His anatomical study of the upper ending of the larynx shows it to be strikingly similar to the structure of a recorder. Next to the drawing he explains how the pipe works in the manner of the human voice. Throughout the notebooks we find Leonardo's works constantly providing a link between the scientist and the artist.

When I undertook to edit the brief anthology which follows, I hesitated for some time over the question of what criteria would determine my choice. Obviously it would be insufficient to compile a pleasant group of pretty passages chosen according to aesthetic norms, just for their suggestive beauty. I needed a thread that would bind the passages into a discursive continuum, and nothing seemed to me as responsive to Leonardo's aims themselves, or as illustrative of his personality, as the theme of knowledge.

The sequence opens with a lively and highly descriptive early passage, taken from the Codex Arundel, in which a youthful Leonardo symbolically stands poised at the mouth of a great cavern, bending to discover "whether it contained some marvelous thing." It ends with several excerpts drawn from his last years. They encompass a world view of extraordinary profundity; here Leonardo's evident awareness of the universal values he expressed creates a tone we can only call solemn. In a consecutive reading, the striking contrast of viewpoint and manner between the passages gives us the measure of the immense distance he had traveled. The intervening passages, arranged in generally chronological order, demonstrate beyond doubt that Leonardo's point of departure was painting, "which alone imitates all the visible works of nature." In Renaissance language imitation has a meaning clearly distinct from that of portrayal, reproduction, or copy: it means the creations of forms analogous to those of nature by following nature's own laws. Hence the definitions of painting as "subtle science" and "true daughter of nature" and the statement that "the painter contends with and rivals nature" must be understood not rhetorically, but literally. Leonardo begins with painting and with the sharpness of optical perception, and draws from painting his means of exploring nature: perspective. While other Florentine painters continued to consider perspective only as an instrument of figurative representation, Leonardo discovered how perspective can become an outstanding instrument for measuring and knowing the physical world.

The optical pyramid, with its sheaf of rays converging on or diverging from a point, and the proportionality of its bases at whatever distance they are drawn to intersect with the sheaf of rays provide him with the means of demonstration. The pyramid further avails him of the ability to quantify the entity of forces that strike a point or a surface. Single rays determine for him the course of forces in motion, as well as the angles of incidence and reflection between the blow of a motor force and the flight of the moved object.

Leonardo has a dynamic and mechanistic concept of the physical world, including the human body and the animal kingdom. According to his theory, four powers move the world and determine the continual transformations that occur within it: gravity, force, accidental motion, and percussion – and the last exceeds in great abundance any of the others. The phenomenon of percussion is created not only macroscopically – by the blow of a heavy body in motion against another body ("mover" and "moved object") – but also by optical rays that strike the eye, thus conveying to it images of things, by sound that strikes the ear, and by all the stimuli that strike the terminal nerves of the senses, awakening sensation. All are phenomena of percussion: water that strikes other water or an intervening obstacle, the motion of air against air, the beating of a bird's wings in the air or the impact of air upon the wings, and the darting of fish in water. "Describe underwater swimming and you will have described the flight of birds."

Leonardo's investigation branches out ceaselessly in every direction. The crossing and recrossing of his thought over myriads of cases and propositions may often seem to meander tortuously and turn in upon itself. But as we progress in reading and understanding his manuscripts, the apparent knot of intricacy dissolves, and we discover that the innumerable variety of subjects addressed by his mind actually constitutes the infinite aspects of one sole power which he tirelessly pursues in all its forms. Descending from a general principle to the interpretation of a particular phenomenon, and from the penetrating analysis of particulars rising again to first principles, he discovers the unbounded variety of their manifestations in nature.

There is no antagonism in Leonardo's mind between art and science. They flow perpetually from one another, each increasing by experience of the other. Only by admitting the participation of every aspect of his work in this ever-growing continuum of mental processes may we understand all its significance, its deep and prolonged resonances. This guides our approach to his prose, where a precise description of a phenomenon, analyzed in its diverse phases by a tightly linked use and reuse of certain key terms, unfolds at last and dilates into splendid images of nature; in his words from Codex Arundel, 94 verso: "The countless images refracted from the countless waves of the sea by solar rays where they strike them produce an immense and continuous splendor over the surface of the sea."

myrar: folla folm for follior

Love only makes me remember, it alone makes me alert

Overleaf: As demonstrated by these different ideas often on the same page. two pages from Windsor (19150 verso), Here are shown notes on motion and Leonardo filled his notebooks with anatomy as well as on optics.

TTO Lacation

windown homes from A anna mediania

no verplichere te metrime northe metricans mende fillions fille acculture selle love openane non collargene , come fimalitures ab

שבלי אות הכתי הירושיי אר אישיים שלי אישיים אישי אישיים אישיים

ה הייה לנוחה בארוחה שיוליסאי יו שלמי שה איזועהאישה שליי יואה י הייהואיאה איזועהאישה שליי יאה י ארי אישהאשה איזעהאישה שליי יאה י ארי אישהאשה איזעהאישה שליי האיז ארי אישהאשה איזעהאישה שליי איז ארי אישהאשה איזעה שלי איזער ארי אישהאשה איזעה שלי איזער ארי אישהאשה איזעה שלי איזער ארי אישהאשה איזער מיי ארי אישהאשה איזער מיי ארי אישהאשה איזער מיי ארי אישהאשה איזער איזער איזער ארי אישהאשה איזער איגער איזער איזער איזער איזער איזער איזער איזער איגער איגער איזער איגער איזער איזער איזער איגער איזער איגער איגער איזער איזער איגער איזער איגער איגערא

which allowing a stran

- Universe programme to as a country of a series of a

1 - 18 Cone (: Whene A: crarte infute to to to an until fune beau Product State of the sundal of the best principle of the best of the press of the p Angle Course Course Security Collection Security Paula

to prove i clive i lan bile bage for profilmente sufuriore à friquente se sector stante pe ני נייד אושי אישר אישר לא וויין לווייולא אושי לא לא אושי לי Unever an experience is any and a light and it Ander a riter warder and the polyner and the strange

A certification of the cost of the cost of the sector of a strate of the sector of the

actro cross place serve prove place server prove by any prove lass of active wayses of more prove prove lass of possible of possible of possible prove prove place prove pr

X

tirato dalla mia bramosa voglia, vago di vedere la gran copia delle varie e strane forme fatte dalla artifiziosa natura, raggiratomi alquanto infra gli ombrosi scogli, pervenni all'entrata di una gran caverna, dinanzi alla quale restato alquanto stupefatto e ignorante di tal cosa, piegato le mie reni in arco e ferma la stanca mano sopra il ginocchio, e colla destra mi feci tenebra alle abbassate ... cigliá. E spesso piegandomi in qua e in là per vedere se dentro vi discernessi alcuna cosa e questo vietatomi la grande oscurità che là entro era, stato alquanto, subito salse in me 2 cose, paura e desidèro: paura per la minacciante e scura spilonca; desidèro per vedere se là entro fusse alcuna miracolosa cosa.

Che alcuno prosuntuoso gli parrà ragionevolmente potermi biasimare coll'allegare io essere omo sanza lettere – gente stolta! Non sanno questi tali ch'io potrei, sì come Mario rispose contro a' patrizi romani, io sì rispondere dicendo: quelli che dell'altrui fatiche

> sè medesimi fanno ornati le mie a me medesimo non vogliano concedere.

Diranno che per non avere io lettere, non potere ben dire quello di che voglio trattare. Or non sanno questi che le mie cose son più da essere tratte dalla sperienzia che d'altrui parola; la quale fu maestra di chi ben scrisse, e così per maestra la piglio e quella in tutti i casi allegherò.

And drawn by my ardent desire, impatient to see the great abundance of strange forms created by that artificer, Nature, I wandered for some time among the shadowed rocks. I came to the mouth of a huge cave before which I stopped for a moment, stupefied by such an unknown thing. I arched my back, rested my left hand on my knee, and with my right shaded my lowered eyes: several times I leaned to one side, then the other, to see if I could distinguish anything, but the great darkness within made this impossible. After a time there arose in me both fear and desirefear of the dark and menacing cave; desire to see whether it contained some marvelous thing.

ince I am not a man of letters, I know that certain presumptuous persons will feel justified in censuring me, alleging that I am ignorant of writing-fools! They do not know that I could reply, as did Marius to the Roman nobles, "They who adorn themselves with the labors of others will not concede me my own." They will hold that because of my lack of literary training I cannot properly set forth the subjects I wish to treat. They do not know that my subjects require for their expression not the words of others but experience, the mistress of all who write well. I have taken her as my mistress and will not cease to state it. **ATLANTICUS** 119v-a

che le loro ragioni non sono confermate dalla isperienza.

La quale è sola imitatrice di tutte l'opere evidenti di natura, per certo tu sprezzerai una sottile invenzione, la quale con filosofica e sottile speculazione considera tutte le qualità delle forme: aire e siti, piante, animali, erbe e fiori, le quali son cinte d'ombra e lume; e veramente questa è scienzia legittima figliola di natura...

l dipintore disputa e gareggia colla natura.

La prospettiva adunque è da esser preposta a tutte le traduzioni e discipline umane, nel campo della quale la linia radiosa complicata dà i modi delle dimostrazioni, nella quale si truova la gloria non tanto della matematica quanto della fisica...

per la quale la sperienzia conferma tutte le cose mandare all'occhio per linee piramidali la lor similitudine; Avoid the teachings of speculators whose judgments are not confirmed by experience.

f you disparage painting, which alone imitates all the visible works of nature, you disparage a most subtle science which by philosophical reasoning examines all kinds of forms: on land and in the air, plants, animals, grass, and flowers, which are all bathed in shadow and light. Doubtless this science is the true daughter of nature....

he painter contends with and rivals nature.

FORSTER III 44v

MS. B4v

f all studies of natural causes, light gives greatest joy to those who consider it; among the glories of mathematics the certainty of its proofs most elevates the investigator's mind. Perspective, which shows how linear rays differ according to demonstrable conditions, should therefore be placed first among all the sciences and disciplines of man, for it crowns not mathematics so much as the natural sciences....

Perspective is the rational law by which experience confirms that all objects transmit their image to the eye in a pyramid of lines. e quelli corpi d'equali grandezze faranno maggiore o minore angolo a la lor piramide secondo la varietà della distanzia che fia da l'una a l'altra. Linie piramidali intendo esser quelle, le quali si partano da' superfiziali stremi de' corpi e per distante concorso si conducano in un sol punto. Punto dicono essere quello il quale in nessuna'parte si pò dividere,

e questo punto è quello il quale, stando ne l'occhio, riceve in sè tutte le punte della piramide.

gni corpo empie la circustante aria della sua similitudine, la quale similitudine è tutta per tutto e tutta nella parte. L'aria è piena d'infinite linie rette e radiose insieme intersegate e intessute sanza occupazione l'una dell'altra, [che] rappresentano a qualunque obbietto la vera forma della lor cagione.

erchè in tutti i casi del moto l'acqua ha gran conformità con l'aria, io l'allegherò per esemplo alla sopraddetta proposizione. lo dico: se tu gitterai in un medesimo tempo 2 picciole pietre alguanto distanti l'una dall'altra sopra un pelago d'acqua sanza moto, tu vederai causare intorno alle due predette percussioni 2 separate quantità di circuli, le quali quantità, accresciendo, vengano a scontrarsi insieme e poi a 'ncorporarsi intersegandosi l'un circulo coll'altro, sempre mantenendosi per cientro i lochi percossi dalle pietre. E la ragion si è che benchè lì apparisca qualche dimostrazione di movimento. l'acqua non si parte del suo sito... E che quel ch'io dico ti si facci più manifesto,

Bodies of equal size produce angles that are more or less acute depending on their respective distances. I call "pyramid of lines" the lines that emanate from the surfaces and outlines of the bodies and, as they converge from a distance, end in a common point. We call a point that which cannot be divided in any way, and that point, situated in the eye, receives in itself the apexes of all the pyramids.

Every body fills the surrounding air with images of itself, and every image appears in its entirety and in all its parts. The air is full of an infinity of straight lines and rays which cut across each other without displacing each other and which reproduce on whatever they encounter the true form of their cause.

MS. A 2v

will demonstrate the proposition that in all cases the motion of water conforms to that of air. If you simultaneously throw two small stones at some distance from each other onto a motionless body of water. you will notice around the places of impact two groups of widening circles which finally meet and merge, one circle intersecting with the other, each having as its center the point of impact. The reason is that despite some evidence of movement, water does not leave its location.... And to ascertain the truth of what I say,

poni mente a quelle festuche che per lor leggerezza stanno sopra l'acqua, che per l'onda fatta sotto loro dall'avvenimento de' circuli non si partan però del lor primo sito, essendo adunque questo tal risentimento d'acqua più tosto tremore che movimento...

> acqua percossa dall'acqua fa circuli dintorno al loco percosso; per lunga distanzia la voce infra l'aria; più lunga infra il foco; più la mente infra l'universo; ma perchè ell'è finita non si astende infra lo infinito.

gni cosa mossa con furia seguiterà per l'aria la linia del movimento del suo motore. Se quello move la cosa in circulo, s'ella fia lasciata in quel moto, il moto suo fia curvo; e se il moto fia principiato in circulo e finito in dirittura, in dirittura fia il suo corso; e così sendo cominciata diritta e finita torta, torto fia il suo cammino. Ogni cosa mossa dal colpo si parte infra angoli uguali del suo motore.

Signi corpo spérico di densa e resistente superfizie, mosso dai pari potenzia, farà tanto movimento con sua balzi causato da duro e solio smalto quanto a gittarlo libero per l'aria. O mirabile giustizia di te, primo motore. Tu non hai voluto mancare a nessuna potenzia l'ordini e qualità de' sua necessari effetti, consider the reeds which by virtue of their lightness remain above water without being displaced by the waves thus created under them, for the stirring of the water is a tremor, rather than a movement....

MS. A 61r

ater struck by water forms circles around the point of impact; the voice in the air creates the same along a greater distance; fire goes still farther, and still farther the mind in the universe; but since the universe is finite, the mind does not reach infinity.

MS. H 67r

very object that is hurled furiously through the air follows its mover's line of motion. If the object is moved and released in a circular motion, its own motion will be curvilinear, and if the motion began as a circle and ended as a straight line, its course will follow a straight line, and if its beginning was straight and its completion crooked, its path will be tortuous. Every object that is moved travels at equal angles from its mover.

MS. A 81v

wery spherical body with a dense and resistant surface, if moved by bodies of equal force, will perform as much movement in leaps caused by hard, solid impact as by throwing it freely into the air. O how wondrous is your justice, Prime Mover! You have willed that no power lack the orders and qualities con ciò sia che una potenzia debe cacciare 100 braccia una cosa vinta da lei e quella nel suo obbedire trova intoppo, hai ordinato che la potenzia del colpo ricausi novo movimento, il quale per diversi balzi recuperi la intera somma del suo debito viaggio. E se tu misurerai la via fatta da detti balzi, tu troverai essere di tal lunghezza qual sarebbe a trarre con la medesima forza una simil cosa libera per l'aria.

gni grave che libero discende, al centro del mondo si dirizza; e quel che più pesa, più presto discende; e quanto più discende, più si fa veloce. Tanto pesa l'acqua che si parte del suo sito per causa della nave, quanto il peso di essa nave appunto.

in mentre che la impressione della potenzia del suo motore in lui si riserva.

> gni piccol moto fatto dal mobile circundato dall'aria, si va mantenendo con l'impeto.

L'aria che con più velocità di mobile è percossa, con maggior somma di sè medesima si condensa. ...essendo l'aria corpo atto a condensarsi in sè medesima quando essa è percossa da moto di maggior velocità che non è quel della sua fuga, of the acts necessary to it. Since a power must hurl at a distance of one hundred braccia an object that it controls, and that object obey its drive, you ordered that the power of the blow must cause new movement, which by diverse leaps recuperates the whole total of its rightful journey. And if the trajectory of those leaps is measured, it is found to be of such length as it would take to draw a similar thing through the air with the same force.

Every weight that falls freely falls toward the center of the earth; those of greater weight fall more quickly, and as they descend their velocity increases. The water displaced by a ship has a weight equal to that of the ship.

FORSTER II2 65v

he continuity of every motion and the motion of every moving body depend upon the maintenance of power of the mover.

VOLO DEGLI UCCELLI 13 (12)r

by an object in space is maintained by its impetus. MS. K3 111 (31)r

hy birds are supported in the air. Air that is struck with greatest velocity of motion condenses the most. Since air is a body capable of condensation when struck with a motion of greater velocity than its own, essa si prieme in sè medesima e si fa infra l'altra aria a similitudine del nuvolo... Ma quando l'uccello si trova infra 'l vento, egli pò sostenersi sopra di quello sanza battere l'alie, perchè quello offizio che fa l'alia mossa contro all'aria stando l'aria sanza moto, tal fa l'aria contro all'alia essendo quella sanza moto.

> S crivi del notare sotto l'acqua, e arai il volare dell'uccello per l'aria.

a scienzia strumentale over machinale è nobilissima e sopra tutte l'altre utilissima, con ciò sia che mediante quella tutti li corpi animati che hanno moto fanno le loro operazioni.

...mia intenzione è allegare prima la sperienza e poi colla ragione dimostrare perchè tale esperienza è costretta in tal modo ad operare.

e quando l'aria si convertansi li elementi l'uno nell'altro, e quando l'aria si converte in acqua pel contatto ch'ell'ha colla sua fredda regione, allora essa attrae a sè con furia tutta la circunstante aria, la quale con furia si move a riempiere il loco evacuato della fuggita d'aria ...e questo è il vento. it then becomes as dense as a cloud.... But when the bird is in the wind, he can support himself upon it without beating his wings, for the function of wings that move against the air when it is motionless is performed by the air moving against the wings when they are motionless.

ATLANTICUS 77r-b

escribe underwater swimming and you will have described the flight of birds. ATLANTICUS 214r-d

AVL echanical science is most noble and useful above all others, for by means of it all animated bodies in motion perform their operations.

... it is my intention first to cite experience, then to demonstrate through reasoning why experience must operate in a given way.

MS. E 55r

he elements are converted into one another, and when air is converted to water by contact with its cold regions, it then furiously attracts to itself the surrounding air, which rushes to fill the vacated place... and this is the wind.

ATLANTICUS 169r-a

creata dal moto, col moto si mantiene. Quando tira vento spiana la rena, e vedi in che modo essa crea le sue onde, e nota quanto essa si move più tarda che 'l vento; e 'l simile fa dell'acqua e nota le differenzie ch'è dall'acqua alla rena.

> ota il moto del livello dell'acqua, il quale fa a uso de' capelli, che hanno due moti, de' quali l'uno attende al peso del vello l'altro al liniamento delle volte. Così l'acqua ha le sue volte revertiginose, delle quali una parte attende a l'impeto del corso principale, l'altra attende al moto incidente e refresso.

Scrivi come li nugoli si compongano e come si risolvano, e che causa leva li vapori dell'acqua dalla terra infra l'aria, e la causa delle nebbie e dell'aria ingrossata, e perchè si mostra più azzurra e meno azzurra una volta che un'altra; e così scrivi le regioni dell'aria e la causa delle nevi e delle grandini, e del ristrignersi l'acqua e farsi dura in diaccio, e del creare per l'aria nuove figure di neve e alli alberi nuove figure di foglie ne' paesi freddi, e per li sassi diacciuoli...

già sopra a Milano, inverso Lago Maggiore, vidi una nuvola in forma di grandissima montagna, piena di scòli infocati, perchè li razzi del sole,

very configuration of dust, smoke, and water that is created by motion is maintained by it. When the wind blows the sands are leveled, and you see how it forms waves, and note how they move more slowly than the wind: consider the waters. and what differences exist between water and wind.

bserve how the movement of the surface of the water

which has two movements,

resembles that of hair.

one of which stems from the weight of the hair

and the other from its waves and curls.

In the same way, water has its turbulent curls, a part of which follows the force of the main current, the other obeying the movement of incidence and reflection.

WINDSOR 12579r

ATLANTICUS 37v-c

how how clouds form and dissolve, how water vapor rises from the earth into the air, how mists form and air thickens, and why one wave seems more blue than another; describe the aerial regions and the causes of snow and hail, how water condenses and hardens into ice, and how new figures form in the air, and new leaves on the trees, and icicles on the stones of cold places....

nd recently above Milan toward Lake Maggiore, I saw a cloud in the shape of an immense mountain covered with fiery stones,

che già era all'orizzonte che rosseggiava, la tignea del suo colore.

E questa tal nugola grande ... non si movea di suo loco; anzi riservò nella sua sommità il lume del sole insino a una ora e mezza di notte, tant'era la sua immensa grandezza. E infra due ore di notte generò sì gran vento, che fu cosa stupente, inauldita; e questo fece nel riserrarsi, che l'aria che infra quella si rinchiudeva, essendo premuta dalla condensazione del nugolo, rompea e fuggia per le parte più debole, scorrendo per l'aria con ispesso tomulto, facendo a similitudine della spugna premuta dalla mano sotto l'acqua, della quale l'acqua di che era imbeverata fugge infra le dita della man che la preme, fuggendo con impeto infra l'altr'acqua.

> ome la chiarezza dell'aria nasce dall'acqua che in quella s'è resoluta e fattasi in insensibili graniculi, li quali, preso il lume del sole dall'apposita parte, rendan la chiarezza che in essa aria si dimostra; e l'azzurro che in quella apparisce nasce dalle tenbre che dopo essa aria si nascondano.

> Doterai nel tuo ritrarre come infra le ombre sono ombre insensibili d'oscurità e di figura... Le cose vedute infra 'l lume e l'ombre si dimosterranno di maggiore rilievo che quelle che son nel lume o nell'ombre.

> > Looni mente per le strade, sul fare della sera, i volti d'omini e donne, quando è cattivo tempo, quanta grazia e dolcezza si vede in loro.

for it was tinged with red by the sun on the horizon. This huge cloud... stood motionless; such was its immensity that its summit contained the sun's light for one hour and a half into night. And within two hours of night it produced so great a wind, it was a stupefying, unheard-of thing; the air contained in it, compressed by condensation, erupted and escaped through the cloud's weakest part, rushing tumultuously, as happens when a sponge is pressed under water by a hand and the water it had absorbed escapes between the fingers of the hand and through the surrounding water. LEICESTER 28r

dissolved into imperceptible drops which take the sunlight from the opposite direction, thereby rendering the air clear; and the blue that appears in the air is caused by the shadows concealed in it.

LEICESTER 20r

that shadows among shadows are imperceptible in density and outline.... Things seen between light and shadow will display much more relief than those seen in light or in shadow. MS. E 17r

bserve how much grace and sweetness are to be seen in the faces of men and women on the streets, with the approach of evening in bad weather. contengano in ne' primi della natura dell'acqua in sé e ne' sua moti; li altri contengano delle cose fatte da e sua corsi, che mutano il mondo di centro e di figura.

b truovo il sito della terra essere ab antico nelle sue pianure tutto occupato e coperto dall'acque salse; e i monti, ossa della terra, con le loro larghe base, penetrare e elevarsi infra l'aria, coperti e vestiti di molta e alta terra. Di poi le molte piogge, accrescimento de' fiumi, con ispessi lavamenti ha dispogliato in parte l'alte cime d'essi monti, lasciando in loco della terra il sasso... E la terra delle spiagge e dell'alte cime delle montagne è già discesa alle sue base e ha alzato i fondi de' mari ch'esse basi circavano e fatta discoperta pianura, e di lì in alcun loco, per lontano spazio, ha cacciato i mari.

si scopre dalla consumazione del corso dell'acqua, che già non fussi superfizie di terra veduta dal sole.

del fondo del mare e il contrario son le cime dei monti; seguita che la terra si farà sperica e tutta coperta dall'acque e sarà inabitabile. the nature of water and its motion; the others contain the things produced by its flow which have changed the face and the center of the world.

LEICESTER 5r

conclude that in oldest times salt waters entirely occupied and covered the earth, and the mountains, skeleton of the earth with their wide bases, penetrated and arose into the air, covered and decked with abundant, deep soil. Since then great rains, enlarging the streams, despoiled with their frequent lavings the high peaks of those mountains, leaving stone in place of soil.... And the earth of the beaches and of high mountain peaks has already descended to their bases and raised the sea bottom which they had surrounded, and uncovered a plain, from which in some places it has driven the seas.

ATLANTICUS 126v-b

by the depredations of the course of the waters which was not once a land surface seen by the sun.

ATLANTICUS 45v-A

The depths of the sea bottom are perpetual, and the peaks of the mountains are not; it follows that the earth will become spherical, covered with water, and uninhabitable.

MS. F 52r

e renderai ragione di tutti li loro uffizi e in che modo s'adoprano e chi li move.

questo vecchio, di poche ore inanzi la sua morte, mi disse lui passare cento anni e che non si sentiva alcun mancamento nella persona, altro che debolezza: e così standosi a sedere sopra uno letto nello spedale di Santa Maria Nova di Firenze, senza altro movimento o segno d'alcuno accidente, passò di questa vita. È io ne feci notomia, per vedere la causa di sì dolce morte: la quale trovai venire meno per mancamento di sangue e arteria, che notria il core e li altri membri inferiori, li quali trovai molti aridi, stenuati e secchi. La qual notomia discrissi assai diligentemente e con gran facilità, per essere privato di grasso e di omore, che assai impedisce la cognizione delle parte...

nella dimostrazione dei muscoli e lor siti, nascimenti e fini, se prima non fai una dimostrazione di muscoli sottili a uso di fila di refe; e così li potrai figurare l'un sopra dell'altro come li ha situati la natura...

il vedere fare la notomia che vedere tali disegni,

ou will take the measure of all the muscles and learn their functions, who moves them, and how they are implemented. ANAT. B 27r

nd an old man, only a few hours before he died, told me that he had lived for one hundred years without experiencing any physical failure other than weakness; and sitting on the bed in the hospital of Santa Maria Nova in Florence, he passed from this life, giving no sign of any accident. And I dissected his body, in order to understand the cause of so easy a death. I discovered that it came to him through a lack of blood in the arteries that fed the heart and the lower parts, which were used up and dried out. I performed this dissection minutely and easily, as there were neither fat nor humors to impede recognition of anatomical parts.... ANAT. B10v

ou will only confuse your representation of the muscles and their location, derivation, and purpose if you first do not show the network of the small muscles; depict them one above the other as nature has placed them....

ANAT. A 18r

ou who claim that it is better to watch an anatomical demonstration

diresti bene se fussi possibile veder tutte queste cose, che in tali disegni si dimostrano, in una sola figura; nella quale, con tutto il tuo ingegno, non vedrai e non arai notizia se non d'alquante poche vene; delle quali io, per averne vera e piena notizia, ho disfatti più di dieci corpi umani, destruggendo ogni altri membri, consumando con minutissime particule tutta la carne che dintorno a esse vene si trovava, sanza insanguinarle, se non d'insensibile insanguinamento delle vene capillare. E un sol corpo non bastava a tanto tempo; che bisognava procedere di mano in mano in tanti corpi, che si finissi la intera cognizione; la qual ripricai due volte per vedere le differenzie. E se tu arai l'amore di tal cosa. tu sarai forse impedito dallo stomaco; e se questo non ti impedisce, tu sarai forse impedito dalla paura coll'abitare nelli tempi notturni in compagnia di tali morti, squartati e scorticati e spaventevoli a vederli; e se questo non t'impedisce, forse ti mancherà il disegno bono, il qual s'appartiene a tal figurazione. E se tu arai il disegno, e' non sarà accompagnato dalla prospettiva; e se sarà accompagnato, e' ti mancherà l'ordine delle dimostrazion geometriche e l'ordine delle calculazion delle forze e valimento de'muscoli; o forse ti mancherà la pazienzia, se tu non sarai diligente. Delle quali, se in me tutte queste cose sono state o no, centoventi libri da me composti ne daran sentenzia del si o del no, nelli quali non sono stato impedito nè d'avarizia o negligenzia, ma sol dal tempo. Vale.

than to look at these drawings-you would be right, if you could see in a single form all the details shown in the drawings; with all your ability, you would not see or get to know in one form more than a few veins. To obtain an exact and complete knowledge, I have dissected more than ten human bodies, destroying all the other parts and removing to the last particle all the flesh surrounding these veins, without any bleeding other than that, nearly imperceptible, of the capillary veins. A single body did not suffice for so long a time; I had to proceed by stages with many bodies to achieve complete knowledge. I did this twice in order to understand the differences. In spite of your love of such investigations, you may be deterred by repugnance; if not, then by the fear of spending the nights in the company of corpses that are cut up and flayed and horrible to look upon. And if this does not deter you, then perhaps you lack the skill in drawing necessary for such representations; and if you can draw, you may have no knowledge of perspective; and if you have it, you may not be versed in geometrical exposition or in the method of calculating the forces and energy of the muscles; or perhaps you are lacking in patience, so that you will not be diligent. Whether or not I possess all these qualities will be attested in one hundred twenty books, whose composition was delayed not by avarice or negligence, ANAT. C 13v but by time alone. Farewell.

e guarderai le stelle sanza razzi (come si fa vederle per un piccolo foro fatto colla strema punta de la sottile acucchia, e quel posto quasi a toccare l'occhio), tu vedrai esse stelle essere tanto minime, che nulla cosa pare essere minore. E veramente la lunga distanzia dà loro ragionevole diminuizione, ancora che molte vi sono, che son moltissime volte maggiore che la stella ch'è la terra coll'acqua. Ora pensa quel che parrebbe quessa nostra stella

in tanta distanzia, e considera poi quante stelle si metterebbe' e per longitudine e latitudine infra esse stelle, le quali sono *seminate per esso spazio*tenebroso.

L N Ili ambiziosi, che non si contentano del benefizio della vita nè della bellezza del mondo, è dato per penitenzia che lor medesimi strazino essa vita, e che non possegghino la utilità e bellezza del mondo.

non ti laldare di conoscere le cose che ordinariamente per sè medesima la natura conduce, ma rallegrati di conoscere il fine di quelle cose che son disegnate dalla mente tua. A f you scrutinize the stars without rays (as is done through a little hole in the end of a small lens, placed so as almost to touch the eye), you will perceive these stars as so tiny that nothing could be smaller. And indeed, the great distance confers upon them a certain diminution, though many of them are several times larger than that star which is our earth and its waters. Now consider what our star would seem at such a distance, and how many stars could be longitudinally and latitudinally interposed between those which are scattered through dark space. MS. F Sr

with the gifts of life and the beauty of the world, are given the penitence of ruining their own lives and never possessing the utility and beauty of the world.

ATLANTICUS 91v-a

investigator, do not flatter yourself that you know the things nature performs for herself, but rejoice in knowing the purpose of those things designed by your own mind.

MS. G 47r

APPENDIX

THE BICYCLE

AUGUSTO MARINONI

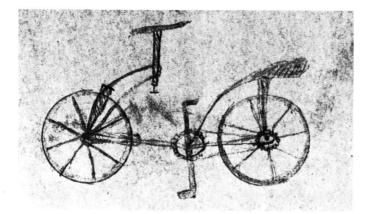

The incredible drawing above recently found on the reverse side of folio 48 recto-b (now numbered 133 verso) in Codex Atlanticus was obviously drawn by a youthful hand. However, the extraordinary vision displayed by the creation of a vehicle that must be balanced on two wheels while in motion, and the advanced mechanical concepts primitively rendered force us to the conclusion that this is actually a copy of someone else's work, presumably Leonardo's.

It is well known that in the 16th century Pompeo Leoni, in order to prevent the dispersion of many loose folios of Leonardo's, glued them onto the large pages of an album which subsequently became known as the Codex Atlanticus. When writing appeared on both sides of a page, Leoni made a window opening in the supporting sheet and glued onto its margins those of Leonardo's sheet. However, when the reverse side did not bear Leonardo's writing, Leoni did not make the opening, and that side remained hidden until a few years ago, when restoration of the codex brought to light every sheet contained within it. Of the present pages 132 and 133, only the rectos, previously numbered 48 recto-a and 48 recto-b, were known to scholars. Today we have access to the respective versos, which offer us the most extraordinary revelation of the codex.

intapia arta 201 S MI AN Inter (and I was 1000 10 94A 100 NH ~1 ·1 ·P ven an

The recent restoration of Leonardo's Codex Atlanticus revealed for the first time the reverse side of numerous pages which have been pasted to mountings for the past 400 years. Folios 48 recto-a and 48 recto-b are shown above as originally mounted and the previously hidden reverse sides are shown in the illustrations on this page. Obviously the two sheets were originally one and were apparently cut apart and rotated 90 degrees before Leonardo used them for his drawings of a fortress above.

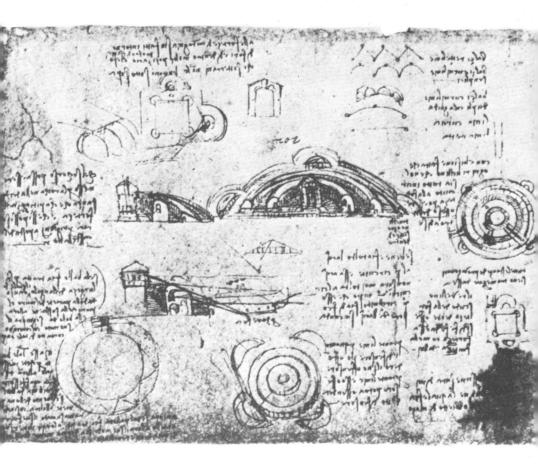

At the end of October 1504 Florence dispatched Leonardo to the port city of Piombino to improve her defenses. He remained there six to seven weeks, during which time he drew detailed plans and made notes for a number of projects. Out of these labors Leonardo evolved a design for a fortress so different its like would not be seen for centuries. In his sketches above, the first modern bastion begins to take form. Outposts on the four corners furnish flanking fire. Concentric fortified rings provide firing positions for the defenders.

The reverse sides of Codex Atlanticus, folios 48 recto-a and 48 recto-b, reveal various drawings which, not being of Leonardo's hand, were considered unimportant by Pompeo Leoni when he assembled many loose folios into what subsequently became known as the Codex Atlanticus. The loose folios were glued on to the large pages of an album and when writing appeared on both sides of the pages, window openings were made in the supporting sheet. But in the case of folios 48 recto-a and rectob no windows were made, concealing the reverse sides for four centuries. The concealed drawings include a caricature of a boy in Renaissance costume, several pornographic sketches, and an amazing depiction of a bicycle.

These drawings are apparently by and about students in Leonardo's studio. One student, Salai, is referred to by name with the inscription "salaj" shown in the enlargement above.

Let us examine folio 133 verso. We immediately note at the upper right what can only be defined as a bicycle, drawn by a youthful hand. The two wheels were drawn with a compass which opened slightly while completing its rotation. The rims of the wheels with eight spokes are colored brown to imitate wood. The chassis is entirely horizontal, with two gears to hold the wheels, but only one is well defined. Against the back hub are propped the braces supporting the large saddle, which has a third point of support at the center of the chassis. The rather strange handlebar is in the form of a T, from which a bolt projects, and is connected to the front hub by two arched and probably flexible rods. To prevent these parts from rubbing it, the wheel is provided with a guard. To the center of the chassis is fixed a gear wheel with large wooden teeth, of cubic rather than pointed shape, in order to withstand traction. It is not clear how the front wheel can be steered. We do not know if the youth copying from another drawing is responsible for some omission or if the problem had not been solved even in the original drawing. But we must surely attribute to the inexperience of the draftsman the disproportionate length of the pedals and the transparency of the wooden-toothed wheel, which looks like a rim without supporting spokes.

While they recognize the unmistakable nature of this machine, the few scholars who have examined the drawing are decidedly reluctant to admit its antiquity. Since the application of the chain-drive to the bicycle goes back only to the end of the 19th century, they propose a dating of the drawing within the early years of the present century. Such a hypothesis, however, collides with insurmountable difficulties: (1) The page in question remained hidden for almost four centuries, and it is unimaginable that 70 or 80 years ago a boy would have obtained from the directorship of the Biblioteca Ambrosiana the permission to view the codex, detach one or two pages, and then draw upon them and glue them back again. (2) Even in that case, he would have drawn a bicycle of a type then existent, not one of wood with wheelbarrow wheels, no means of steering, and the teeth of the central gear so squared off that they could not be fitted to the chain. (3) The odd toothed wheels and the chain coincide exactly with those drawn by Leonardo in Codex Madrid I, folio 10 recto. (4) We cannot separate the bicycle from the other drawings visible on folios 132 verso and 133 verso of the Codex Atlanticus. Actually they were drawn when the pages were united as the two halves of one page. Reuniting them, we see that another hand has drawn, also in pencil and from left to right, two pornographic drawings obviously meant as a joke, over which, on the right-hand side, is written clearly salaj, that is, Salai, the name of Leonardo's pupil, model, and servant. Further up, to the left of the bicycle, we see the caricatured bust of a Renaissance boy with thin, long hair, his suit tied with elegant

fastening cords, his face terribly deformed. The receding chin, missing cheeks, and pointed eyes under hawk-like brows accord with the hooked nose transformed into a beak. It is more than believable that the caricature represents the same Salai already mocked in the obscene drawings. Besides, other more or less obscene drawings appear on the verso of folios 73 and 154b, as well as 24 recto-b and 55 verso-b.

These drawings bring us within the intimacy of Leonardo's studio, where paper for writing and drawing was always readily available and where many young pupils lived and worked: Salai, the somewhat older Marco d'Oggiono, Gian Antonio Boltraffio, and others. One of them (Salai?) copied on one sheet of this paper his

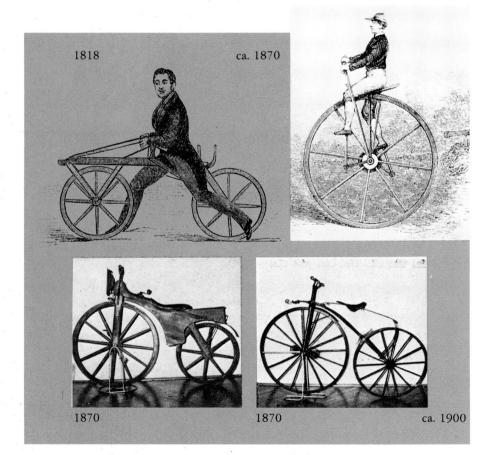

master's drawing – we say he copied it, because we cannot attribute to a mere boy the formidable foresight that anticipated today's bicycle by three or four centuries.

The bicycle depicted in Codex Atlanticus is apparently made of wood, with equal-sized wheels and with a rear-wheel chain drive. In the series of drawings below showing the development of the modern bicycle from its beginning around 1817, the same elements are found again, but never in the same vehicle. The earliest versions were made of wood, but they lacked the chain-drive mechanism. By the time they had a rearwheel chain drive, they were made of metal.

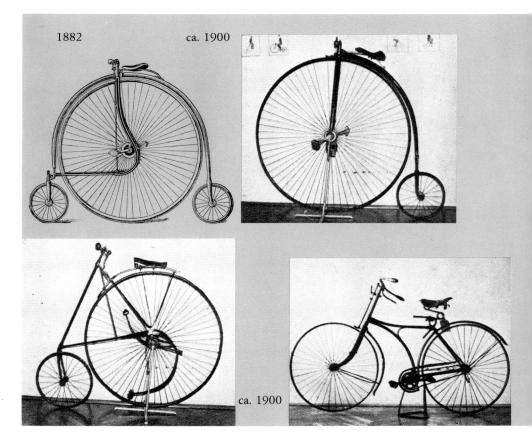

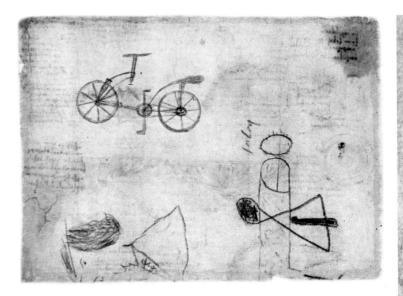

It is impossible to know how many omissions from the original were made when this copy was drawn. However, the depiction of the gears and the chains agree completely with Leonardo's drawings found in Codex Madrid I and Codex Atlanticus (page 165).

The dream of Icarus, which long preoccupied Leonardo, is less original than the subtle and brilliant idea of traveling while balanced on only two wheels. And then a fellow student and worker, perhaps a bit older and cleverer, drew his ribald satire on the same sheet. The beautiful face of Salai, which to the master would suggest faces of men and women full of sweetness, is fiercely distorted and likened to some kind of bird. The joke probably vented resentment against the possessor of the privileged beauty, destroying the very part of him that was most splendid, the face. But it also could represent the vendetta of Marco or Gian Antonio against the little "stubborn one, thief, liar, glutton," who robbed indifferently strangers, companions, and the very master, who was like a father to him. Further down on the page, the satire continues with the obscenity of the larger, more complicated drawing. The more heavily covered parts of the obscene drawings have left their imprint upon the opposite half of the original sheet, and measuring the respective distances of drawing and imprint from the margins of the two current folios, we note

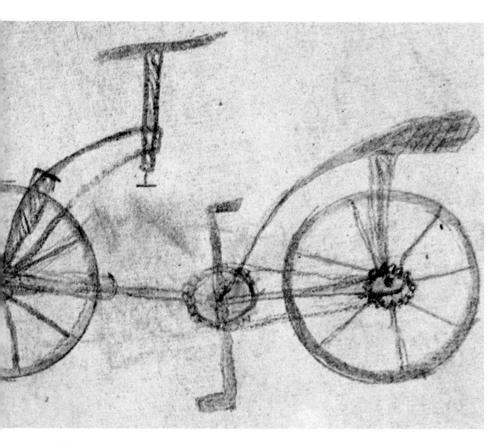

that folio 132 has lost 5 to 7 millimeters. We do not know for how many days, months, or years afterwards Leonardo, then occupied with military problems, used the divided sheet for notes and drawings of powerful fortifications. We do not even know whether the sheet was cut by himself or by someone else. The Codex Atlanticus contains many other examples of large sheets folded and worn out along the fold to a degree that might have suggested cutting them. However, it is certain that Leonardo wrote upon the already cut sheet without giving importance to what the pupils had drawn there. It was his custom to utilize for economy's sake the reverse or the blank spaces of sheets already used by others. He rotated the two half sheets by 90 degrees, and where the vertical fold had been there appeared the upper horizontal margin of the two new pages, as indicated by the succession of lines of writing. If the sheet had still been uncut, Leonardo, as in many other instances, would have begun to write from what is now the right-hand margin and continued in lines parallel to it.

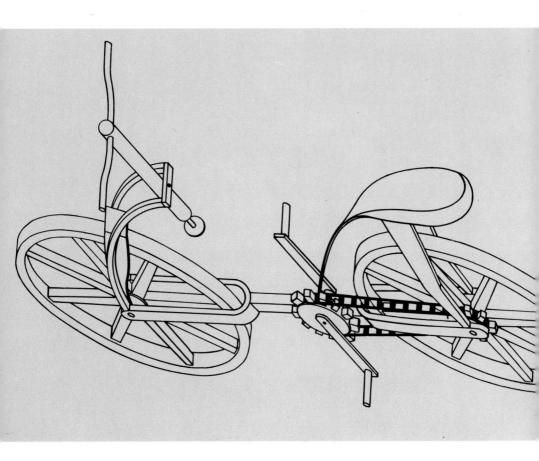

Not even Pompeo Leoni paid attention either to the obscene drawings or to that of the bicycle, which represented not a physically existing object, but an idea still gestating. To become a reality, the idea required the final solution of some challenging problems, such as the matter of steering and the adaptation of the large squared-off teeth with their jutting corners to the links of the chain, not to mention weight and friction – but the idea in itself and the solutions were of so impressive a genius that the sculptor Pompeo Leoni could not grasp it. To him does go the credit for having saved this sheet from destruction by gluing it in his great album, removing it for nearly four centuries from the eyes of others but guaranteeing thereby the antiquity and authenticity of a stunning discovery.

It remains, if possible, to fix the date of the drawing. The hypothesis that the caricature as well as the other drawings concern Salai encounters a not insurmount-

At left is an axonometric projection by Antonio Calegari of the bicycle sketch. This reconstruction corrects the disprocontradictions portions and which can be noted in the distances between the spokes, in the steering bar supports, and in the length of the pedals. The reconstruction further contains the addition of a second support for the rear wheel, and completes the driving gear, which has been made solid, as Leonardo drew it in Codex Madrid I, folio 10 recto (bottom, right). Notice the square shape of the teeth which make the design impractical. Leonardo worked on this problem in depth, and in Codex Madrid I, folio 5 recto (above, right), he draws gears with rounded teeth, which would facilitate the functioning of a chain.

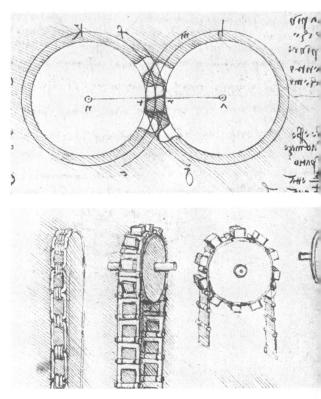

able obstacle: Salai entered Leonardo's house in 1490, aged 10 and was a beautiful boy with "curly hair in ringlets," a feature that does not appear in this intentionally distorted portrait. But even the elimination of the charming curls could be intentional. A straight line above the head suggests the idea of an unfinished hat. It would be useless to claim for a deforming and carelessly tossed-off drawing a true resemblance to the much-maligned boy. From all indications, however, we can speculate that Salai must have been 12 or 13 years old when drawn, which brings us to approximately 1493, and to a coincidence that is scarcely negligible: Leonardo was at that time sketching Codex Madrid I, on whose tenth folio he drew the same toothed gear and chain which we now view with astonishment – on "his" bicycle.

"He who doesn't treasure life, is not worthy of it."

Leonardo da Vinci

LEONARDO'S LIFE

A CHRONOLOGY

Left: Self-portrait of Leonardo from Windsor 12579 recto.

Preceding pages: The enlightenment of human thought is the theme of this Renaissance fresco done in the Vatican by Raphael (1483–1520). Plato is shown as an old man in the center making a point clear to his pupil, Aristotle. Surrounding the two men are philosophers and scholars of antiquity. Socrates stands in the middle of the left half of the fresco in left profile, dressed in a green toga and involved in heated debate. Lying on the steps and reading is Diogenes. To his right foreground, Euclid demonstrates geometrical principles. Euclid, however, has received from Raphael the face of the Italian Renaissance architect Bramante (1444-1514).

The 67 years that made up the life of Leonardo da Vinci embraced one of the most tumultuous and creative eras in human history. Events during that period, commonly called the Renaissance, helped set the stage for the modern world. His lifetime saw the development of the printing press, the discovery of the New World and the sea lanes to the Orient, and a burst of creativity in general.

At the time of his birth in 1452, in Vinci, near Florence, Italy had been rapidly moving away from the medieval era. This movement had begun on a scholarly level with the humanist writers, but was clearly linked with scientific developments, ecclesiastical change, and the growth of capitalistic rather than feudal economic structures.

By the late fifteenth century, the Renaissance was poised between the humanist links to antiquity and the challenges of new social, political, economic, scientific, and ecclesiastical developments. The world was ready for an artist who could go beyond art, a scientist whose curiosity accepted no limitations, a man who could go from the ancient world to a modern one.

On the following pages are a brief account of his boyhood and an illustrated chronology of his adult life, his works, and the cultural and political events that helped shape Leonardo's world.

AN ILLUSTRATED CHRONOLOGY OF LEONARDO

Here begins an illustrated chronology in capsule form of the life and works of Leonardo da Vinci. Section I is underscored by a band of various shades denoting the lifetime itinerary that took him from his birthplace, Vinci, to retirement and death in France – at Cloux, near Amboise – 67 years later. Section II presents a sampling of Leonardo's diversified works for which documentation exists.

1452

I HIS LIFE

Of his youth Leonardo says virtually nothing in the many notebooks he left. His formal education most likely consisted of reading, writing, and basic mathematics. Later he would bemoan his lack of a scholar's education and would struggle to master Latin and geometry. Perhaps more of significance in shaping the artist was the breathtaking landscape over which he roamed as a boy – with its vineyards, pines, and tumbling streams still one of the most beautiful in Italy. Art was regarded by many as a low calling, and ordinarily the boy would have been destined to follow his forebears as a notary. One explanation for his father's willingness to let him become a painter is presented below.

VINCI

II HIS WORK

There exists no documentary evidence of works executed by Leonardo during his first 20 years. But a story has been handed down of an early painting that foreshadowed both the mature artist and the ingenious creator of court amusements. A peasant is said to have asked Leonardo's father Ser Piero to get a wooden shield decorated for him in Florence. Ser Piero gave it instead to his son. Leonardo painted on the shield – from his own collection of lizards, bats, and other animals – a monster so artfully fearsome that it startled his father. Ser Piero bought another decorated shield for the peasant and sold Leonardo's for a handsome profit. Thus convinced there was a market for Leonardo's talent, so the story goes, he decided to apprentice his son to the noted Florentine artist Andrea del Verrocchio. = Illustration

 \dagger = Date of death

1469 1470 1471 1472 Leonardo's father lives in Palazzo del Podestrè in Florence ; Leonardo begins apprentice-Leonardo's name is ship in Verrocchio's■ listed in the register workshop with of Florentine painters, Botticelli, Perugino, The Guild of Lorenzo di Credi. St. Luke. com mercato ip & um do > Qin S Anb Under Lorenzo de' Medici (the Magni-LORENO DIPLERO ACVG A DIPINTORI LIONARDO ASPIERO DEVINITALININTORI LVCA-DIFVOSINIO-DILVCA ficent), Florence is the center of the Renaissance and humanism in Italy. FLORENCE No work by Leonardo known from this period.

January: Commission to Leonardo for the altarpiece of the chapel in the Palazzo della Signoria. Later executed by Filippino Lippi. Jan. 10: Receives commission for altarpiece in the Palazzo Vecchio. Mar. 14: Leonardo receives first payment for altarpiece in Palazzo Vecchio.

1479 1480 View of Florence during the time of Leonardo.

1481

Monastery of S. Donato a Scopeto commissions the Adoration of the Magi, Florence, Uffizi. Sept. 28: Monks of S. Donato make last payment for Adoration of the Magi.

1478-1518: Codex Atlanticus. 1478-1518: Windsor Collection Last third of 1478: Pen drawing of two heads and mechanical devices. Florence. Uffizi. The folio is torn: at the bottom one can read, "...ber 1478 I started the two Virgins Mary." Benois Madonna, Leningrad, Hermitage, 1478-1480: Portrait of Ginevra Benci, Washington, National Gallery of Art.

Dec. 28: Drawing of Bernardo Bandini Baroncelli, ■ murderer of Giuliano de' Medici, Bayonne, Musée Bonnat.

1481: Adoration of the Magi, ■ Florence, Uffizi.
1480–1518: Codex Arundel.
1480: Leonardo paints St. Jerome, Rome, Vatican Picture Gallery.

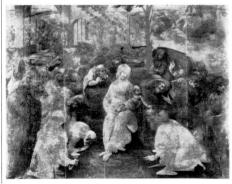

1482	1483	1484	1485
Leonardo goes to Milan without having completed the Ado- ration, and will stay there until the fall of Lodovico il Moro • in 1499.	Apr. 25: The Brethren of the Immaculate Conception commis- sion Leonardo (and the De Predis broth- ers) to paint the altarpiece in their Chapel of San Francesco il Grande. The painting is to be the Virgin of the Rocks.		Apr. 23: Leonardo receives a commission to do a Nativity for Matthias Corvinus, King of Hungary.
MILAN			
	1483–1486: Leonar- do paints the <i>Virgin</i> <i>of the Rocks</i> , ■ Paris, Louvre.	This drawing a can be dated among the first studies for the bronze statue dedi- cated to Lodovico il Moro's father, Francesco Sforza. Windsor 12358r.	1484–1488: Leonar- do paints the portrait of Cecilia Gallerani, ¶ mistress of II Moro, the Lady with an Ermine, Cracow, Czartoryski Gallery.

1491

Studies by Francesco di Giorgio Martini, and note by Leonardo. July 22: The 10-yearold Salai (Jacopo dei Caprotti) comes to live with Leonardo.

days: Tournament to celebrate the marriage of Lodovico Sforza with Beatrice d'Este. (Painting by Leonardo, Milan, Ambrosiana).

1492

1493

July 16: "Caterina" (Leonardo's mother?) is living in Leonardo's house.

November to Dec. 20: Exhibition of a fullscale model of

the horse. Casting discussed in Codex Madrid II 151v. 1493-1495: Codex Forster II₁, II₂, III. 1493-1499: Ms. H.

Leonardo paints the Portrait of a Musician, Milan, Ambrosiana. Ms. C, folio 15v, "On April 23, 1490, I started this book and restarted on the horse."

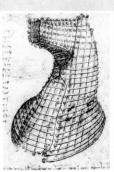

May 17: Preparing to cast II Cavallo, Codex Madrid II 157r. 1491-1493: Codex Madrid II folios 141-157.

Ms. A. 1492-1497: Codex Madrid I.

1495	1496	1497
Leonardo visits Flo- rence to see the new great hall of the gov- erning council.	Friendship and collaboration with Luca Pacioli. Jan. 31: The Danaë play is presented at Gian Francesco Sanseverino's home.	Matteo Bandello in his <i>Novelle</i> writes that he saw Leo- nardo painting from dawn to sunset.
	1495–1498: Leo- nardo paints the <i>Last</i>	
1495–1497: Deco- ration of the Sala delle Asse (detail■), Milan, Sforza Castle. Ca.1495–1497: Ms.M. 1495–1499: Ms. I.	Maria delle Grazie. Leonardo's drawings of the "regular	Ms. L (also 1502– 1503). June: The Last Sup- per is nearly done.
	Leonardo visits Flo- rence to see the new great hall of the gov- erning council.	Leonardo visits Flo- rence to see the new great hall of the gov- erning council. Friendship and collaboration with Luca Pacioli.• Jan. 31: The Danaë play is presented at Gian Francesco Sanseverino's home. 1495–1497: Deco- ration of the Sala delle Asse (detail•), Milan, Sforza Castle. Ca.1495–1497: Ms. M. H95–1499: Ms. I.

1499

Apr. 26: Donation of

Dec. 14: Leonardo

ing sent 600 gold

to his account in Florence.

vineyard is registered.

leaves Milan after hav-

florins to be deposited

Feb. 9: The "laudable and scientific duel" at the Sforza Castle, supervised by Lodovico il Moro. Participants: Leonardo, Pacioli, and theologians, teachers, and physicians. Oct. 2: Leonardo receives a vinevard from Lodovico il Moro. Pacioli writes that Leonardo has just finished a book on painting and is finishing a treatise on "forces and weights."

1500

February: In Mantua with Pacioli. March: In Venice. Leonardo travels over all the Venetian state. Apr. 24: Back in Florence, still with Pacioli.

1501

Apr. 3: In a letter to Isabella d'Este, Novellara writes about the cartoon Leonardo has done for a Virgin and St. Anne.

MANTUA VENICE FLORENCE

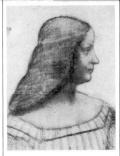

In Mantua, draws cartoon for *Portrait of Isabella d'Este*, ■ Paris, Louvre. Plans a dam in the Isonzo valley in order to flood the country to prevent Turkish invasion.

Apr. 4: Letter from Novellara mentions that Leonardo is working on the *Madonna with the Yarnwinder*.

1498–1499: Draws cartoon for the Virgin and Child with St. Anne, ■ London, National Gallery.

1502	1503	1504	1505
Aug. 18: Cesare Borgia = sends letter hiring Leonardo as his chief architect and military engineer. Travels with Borgia and Machiavelli in Romagna.	March: Back in Flo- rence. Draws money from his account.	Jan. 25: Asked about the most desirable place to display Michelangelo's <i>David</i> . Receives monthly sums of money for painting the <i>Battle of Anghiari</i> . July 9: tSer Piero da Vinci, Leonardo's father. Nov. 1 to 30: At Piombino (Codex Madrid II, folio 15 recto and others).	Receives more money for the <i>Battle of</i> <i>Anghiari.</i>
ROMAGNA	FLORENCE	1	PIOMBINO
Map of Imola (Wind- sor 12284) * and topographic studies executed in the ser- vice of the Duke Valentino, Cesare Borgia. Ms. L.	1503–1506: Cartoon and mural painting of the <i>Battle of Anghiari</i> (detail of a sketch, [■] Windsor 12326r). 1503–1505: Codex Madrid II folios 1–140. Invents relief etching.	1504–1505: <i>Mona</i> <i>Lisa</i> • (portrait of Mona Lisa del Gio- condo), Paris, Louvre.	Drawing from the Co- dex on the Flight of Birds, folio 8 recto. Codex Forster I ₁ .

1506	1507	1508	1509
May 30: Leonardo leaves Florence for temporary return to Milan. Aug. 18: Governor of Milan requests three- month extension of Leonardo's leave from Florence governing council. Aug. 28: Council grants final extension for Leonardo to remain in Milan until the end of September.	Leonardo meets Melzi. Jan. 12: Still in Milan. Louis XII wants Leo- nardo in his service. Mar. 5: Leonardo in Florence. July 26: Leonardo in Milan in the service of King Louis XII; is referred to as "our dear and well-loved Leonardo da Vinci, our regular painter and engineer." Sept. 18: Back in Florence.	July: In Milan. October: Leonardo receives money and lends part of it to Salai.	
MILAN	FL. FL	ORENCE MILA	N
Study for the <i>Leda</i> , "Windsor 12518. Ca. 1506: Codex		Several booklets of Codex Arundel "start- ed in the house of	

Windsor 12518. Ca. 1506: Codex Leicester. Works on Trivulzio's monument.

Study for settling of the Adda, ■ Windsor 12399.

Piero di Baccio Mortelli on March 2, 1508." Ca. 1508: Ms. D. Ca. 1508–1509: Ms. F.

1509–1510: Paints *St. Anne*, ■ Paris, Louvre. 1509–1512: Ms. K₃. Apr. 30: Leonardo solves a problem in geometry (Windsor 12658, 19145).

1510

1511

1512

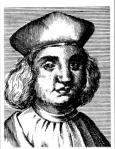

Leonardo works with Marcantonio della Torre,■ professor of anatomy. Oct. 21: At Milan Cathedral to do the stalls of the choir.

Winter: Anatomy Ms. A; on folio A 17 (Windsor 19016) one can read "this winter of 1510 I think I will finish all this anatomy." 1510–1516: Ms. G.

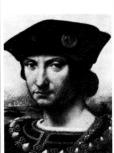

February: †Charles d'Amboise, ■ Leonardo's patron preceding his services for Louis XII in 1507. 1510–1511: Stipend from Louis XII.

1513

Mar. 25: The administration of the Milan Cathedral asks Leonardo for advice. Sept. 24: Leonardo leaves Milan with friends and pupils. Oct. 10: In Florence. Dec. 1: Goes to Rome; has a studio in the Belvedere of the Vatican.

FL. ROME

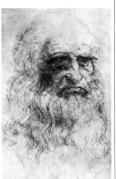

Ca. 1512: Selfportrait,■ Biblioteca Reale, Turin.

1513–1514: Ms. E. Two paintings now lost, for G. B. Branconi. 1513–1516:Leonardo paints *St. John the Baptist,* Paris, Louvre. 1514

1515

1514–1516: Living in Rome but travels often. Spring: In Civitavecchia. Sept. 25: In Parma. Dec. 14: In Rome.

Mar. 17: †Giuliano de' Medici, patron of Leonardo. Leonardo in Florence. Dec. 9: Leonardo in Milan. Letter to his steward in Florence. Trip to Tivoli looking for ancient ruins.

1516

Leonardo in Rome, leaves for France in the winter with Salai and Melzi, I who will later take most of Leonardo's inheritance.

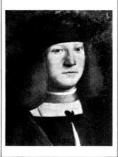

1517

Jan. 17: Leonardo in Romorantin with Francis I; plans a castle for the Queen Mother. Ascension Day: Leonardo at Cloux near Amboise.

Ca. 1514: *The Deluge*, ■ Windsor 12380.

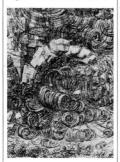

Sends a mechanical lion to Lyon for the coronation procession of King Francis I (July 12). Projects for the stable of Giuliano de' Medici and for the reclamation of Pontine Marshes. Ca. 1516: A young man on horseback wearing a masquerade costume, ■ Windsor 12574. Notes on the dimensions of St. Paul's, Rome, in Codex Atlanticus 172v.

Geometric and architectonic studies.

Excerpts from Leonardo's Testament

The said Testator desires

to be buried within the church of Saint Florentin at Amboise, and that his body shall be borne thither by the chaplains of the church.

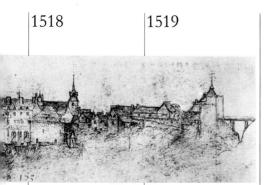

June 19: Plans festival at Amboise for the wedding of Lorenzo di Pietro de' Medici and Madeleine de La Tour d'Auvergne.

The Castle of Amboise. • Apr. 23: Last will. May 2: Death. Buried in Amboise.

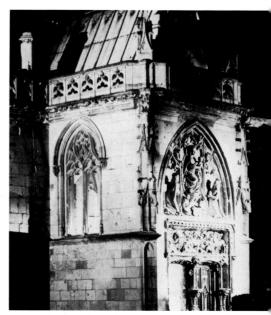

Leonardo was buried at the Church of St. Florentin in Amboise, France.

Ca. 1518: One of Leonardo's last drawings, ■ Windsor 12670v.

FOOTNOTES

THE MECHANICS OF WATER AND STONE

- ¹ Codex Atlanticus, fol. 46r-b.
- ² Codex Madrid I, fol. 169r.
- ³ Ibid., fols. 114v, 115r, 124v.
- 4 Ibid., fol. 125r.
- ⁵ In particular, fols. 114v and 115r.
- 6 Codex Madrid I, fol. 124v.
- 7 Ibid., fol. 115r.
- ⁸ Ibid., fol. 33r.
- ⁹ Ibid., fol. 150v.
- ¹⁰ Codex Atlanticus, fols. 20r, 206r-a, 351r-a. Codex Leicester, fol. 11r.
- ¹¹ It is illustrated in Codex Madrid I, fol. 134v.
- ¹² Manuscript F, fol. 53v. See also Manuscript F, fol. Or, and Manuscript I, fol. 73v.
- 13 Codex Atlanticus, fol. 7r-b.
- ¹⁴ Codex Arundel, fol. 241r.
- ¹⁵ See Codex Madrid I, fol. 142v.
- ¹⁶ Ibid., fol. 140v; Codex Forster II₂, fol. 92r.
- ¹⁷ Codex Madrid I, fol. 143r.
- 18 Ibid., fol. 113v.
- ¹⁹ For example, ibid., fols. 139r, 139v, 140v.
- 20 Ibid., fol. 139r.
- 21 Ibid.
- 22 Ibid., fol. 84v.

LEONARDO'S WRITINGS

- ¹ Fols. 2v-3r.
- ² On fol. 3v.
- It may be assumed that the "small" books are in sextodecimo (in Melzi's list they are called "booklets") and the "still larger" books in octavo or in quarto. For the 2 "larger" books we should be tempted to think of Manuscript C and Codex Leicester, the only 2 "in folio" in all subsequent lists. Manuscripts D, E, F, and G, Codex Forster I1 (i.e., the first part of Forster I), and the Codex on the Flight of Birds, written either in 1505 or in the following years, could not be among the 16 in quarto or in octavo; those that could be are

Manuscripts A and B, Codex Forster I2, the Codex Trivulzianus, both parts of Codex Madrid I, at least the 17 folios on the "horse" of Codex Madrid II which were afterwards bound there together with the rest of it, a notebook on anatomy. Among the 25 "small books in sextodecimo could be Manuscripts L and M, the 21 manuscripts (I1 and I2), the 3 H manuscripts, perhaps the first of the 3 K manuscripts, the 2 Forster II codices, and Forster III

- ⁴ Codex Madrid II included.
- ⁵ In the manuscripts that exist today we can in fact read the following alphabetical marks made by Leoni: A, B, C, D, G, L, O, T, W, Y, W, and perhaps Z, then BB, II, KK, LL, NN, OO, SS.

Evidently the letters of the alphabet were not enough to mark all of them and therefore Leoni recommenced the alphabetical series using double letters. We deduce from this the loss of the manuscripts marked E, F, H, I, M, N, P, Q, R, S, U, AA, CC, DD, EE, FF, GG, HH, MM, PP, QQ, RR; we cannot say with certainty whether any manuscripts exi-sted beyond SS or how many there may have been. Let us say that, adding to the 19 surviving manuscripts the 22 that have disappeared, 5 are still needed to make up the number 46 - without by this affirming that 46 was the last number of the list. We consider 50 to be an acceptable approximate figure.

⁶ There remains a little problem as yet unsolved. The symbols for a single letter of the alphabet are almost invariably followed by an *e* (for which an *a* is substituted only once) in tiny characters, while the symbols for double letters are not: Be 100, Da 114, Le 17, Ge 55, Xe 64, Ye 46, Te 91, Oe 38, We 93. The simplest explanation would be that the writing reflects the pronunciation of the consonants: Be, Ge, Te, etc.; but it does not apply to Le, Da, Oe, C, and Ye, and perhaps not to Xe and We. On the whole, the anomalies seem excessive.

- On the other hand, Codex Madrid II was still divided into two distinct parts to which Leoni applied the marks C and L. In fact C 140 can be read on fol. 140, and Le 17 can be read on fol. 157. Even from its unusual composition and from the presence of various half sheets, this second part of only 17 folios would seem to be what remains of a larger unit that had already been reduced to its present dimensions at the time of Leoni. Later the two parts of Codex Madrid II were bound together and someone took care to unify the numeration, changing the numbers I to 17 of the L codex into the numbers 141 to 157 by placing the figure 14 in front of the first numbers which went from 1 to 9 (but whoever was responsible inadvertently wrote a 12 which he then corrected to 14). The numbers that followed, on the other hand, were written beneath the old numbers 10, 11, etc., which were partly crossed.
- 8 With a certain approximation we could put the series of manuscripts into the following order: between 1485 and 1490 B, Trivulzianus, Forster I2, part of Forster III and some folios of Anatomy B; 1490 C; 1492 A and also Madrid II1 that reaches 1493. Madrid I carries the date of January 1, 1493 in a note added later; therefore it was started in 1492 and was perhaps continued until 1497. Around 1494 the 3 manuscripts H were written, between 1493 and 1496 part of Forster III, between 1495 and 1497 the 2 Forster II. Between 1497 and 1499 M and I (but M precedes I). In the same years the manuscript L was

started and it was continued until about 1503, when Madrid II, which stretches to 1505, was started. Contemporarily were written K1 (1504) and part of K2 which was still being written for some years. In 1505 the Codex on the Flight of Birds and Forster I1 are followed by Leicester, D, and F (about 1508). During these years the study of anatomy was intensified: in fact the greatest part of the folios gathered in the "Quaderni di Anatomia" was written between 1506 and 1513. The last manuscripts spread over a certain number of years: K3 between 1509 and 1512, G between 1510 and 1516, E between 1513 and 1514. The great number of sheets gathered in the Codex Atlanticus, the Codex Arundel and the Windsor Collection cover a long period of time. It is not easy to date every single folio. Important contributions on matters related to chronology have been made by scholars such as Calvi and Giacomelli and, more recently, Pedretti and Clark; but it is a difficult problem, and much remains to be done.

- ⁹ Examples of this type are Forster I1, Forster II2, C, Madrid I, On the Flight of Birds, Leicester, and the notebooks on anatomy. In actual fact, however, not one of these manuscripts corresponds to an organic, completely unitary treatment.
- ¹⁰ Madrid II was originally made up of 9 quires, each containing 8 small sheets folded so as to form 16 folios (later numbered on the recto only by Leoni), or 32 pages. They should make a total of 144 folios, but the present numeration goes only as far as 140, because of the loss of 1 sheet (or 2 folios, between 133 and 134) in the ninth quire, of half a sheet (a folio between the first and the second) in the first quire and because of the repetition, through oversight, of

number 62. We know that the "correct number" for making up a volume was normally 6 quires with a total of 96 sheets. Perhaps the volume grew during the course of its composition.

- ¹¹ Still blank today are fols. 7v, 12r-14v, 20r, 30v, 40v, 51v, 52r, 54r, 57v-60r, 83r, 103r-104r, and 128v-130r. In many cases Leonardo goes back, even after several years, to the pages already written on and fills up the unoccupied spaces with new notes. He sometimes uses his black or red pencil to write, sometimes a pen; he sometimes traces over with the pen what he has written in red chalk.
- ¹² Perhaps the first five if we count the two lost ones, and on fols. 3r, 15r, and 16r.
- ¹³ Fols. 16v, 17r and-v, 18v, 19r and-v, 20r and-v, 21r.
- 14 Fols. 22v-23r, 52v-53r.
- ¹⁵ Fols. 64r and 126r.
- ¹⁶ To fol. 140v.
- ¹⁷ Here he proceeds in the opposite direction from that of the numeration of the pages up to 138v-in other words, from the definition of "point, line, area" to the first proposition.
- 18 Placed at the top of 112r.
- ¹⁹ Some of the pages involved were grouped as follows: 64v-75v, 80v-82v, 105r-120v, 130v to the end.
- ²⁰ The list of clothes is on fol. 4v. ²¹ An example occurs at the end of Manuscript B on the verso of the cover, where Leonardo wrote a series of separate notes. The first three read Trova Lodovico M°- Della carabe inelle Pandette - Il Vicario (the capital letters are mine apart from M°). They are three independent memoranda, the second of which refers to the fact learned by Leonardo that Justinian's Digest of the Roman civil law (Pandette) speaks of yellow amber (carabe). But the existing transcriptions of Manuscript B read della carne nel panetto. Accordingly, Ravaisson-Mol-

lien, making a single note of the first and second memoranda, translated thus: Trouve, M. Ludovic, de la chair dans le petit pain ("Find, M. Ludovic, some meat in the small loaf"). At this point Calvi intervened, objecting that in Milanese dialect panetto meant fazzoletto ("handkerchief"). So someone was hiding meat in his handkerchief. Searching through the archives of Milan, Calvi discovered edicts that the Vicario of Milan of Leonardo's period had issued against black marketeers in times of famine.

- ²² The majority of readers have seen only anthologies, such as those of Richter, McCurdy, Solmi, Fumagalli, and Brizio.
- ²³ Manuscript B, the Trivulzianus, and part of Anatomy B.
- ²⁴ De re militari, De ponderibus.
 ²⁵ Including the Rudimenta grammatices of Perotto and Pulci's Vocabolista.
- ²⁶ The list in Codex Madrid II of the books in Leonardo's possession in 1504 records grammars of Priscian and Donatus (*Maior* and *Minor*, Latin and Latin-Italian), Perotto's *Rudimenta*, two vocabolisti, the Synonima of Flisco, the Doctrinale of Alexander de Villa Dei, and two books on rhetoric.
- 27 It seemed strange to him that dividing two-thirds by threequarters would give eightninths, a quantity greater than the dividend (Codex Atlanticus, fol. 279r-c). He proposed a very simple but absurd rule for finding the square and cube roots of any number, defining the root as a fraction of which the numerator alone is multiplied by itself and supplies the square or cubic number required. This method would give the cube root of three, for example, as three-ninths, because three-ninths by three-ninths give would twenty-seven ninths, or three (Codex Atlanticus, fol. 245r-b; Codex Arundel 200r). It probably did not

take him long to notice that this method was not very safe, and he noted in the Codex Atlanticus (fol. 120r-d), "Learn the multiplication of the roots from Master Luca," and ended by transcribing from Pacioli's *Summa de arithmetica* into the Atlanticus all the rules for doing operations with fractional numbers.

- 28 Manuscript M, fol. 19r.
- ²⁹ Codex Madrid II contains a copy of a version in the vernacular of the first pages of that classic book. We also know from the list of books that Leonardo had in his possession that year a Latin edition of Euclid and an Italian version of the first three books of the same author.
- ³⁰ Fols. 72v, 75v.
- ³¹ In De expetendis et fugiendis rebus. Leonardo refers to one of the fundamental passages by Valla on this subject in the Codex Arundel (fols. 178v-179v) and translates it into Italian. The translation is correct, but the little alphabetical letters that refer to the geometric drawings are often so incorrectly transcribed as to render the text incomprehensible. The handwriting, too, is rather unusual: not close and compact as when Leonardo makes a fair copy, and not abounding in changes of mind and cancellations as when he writes the first draft. A probable explanation that would resolve our doubts would be that Leonardo was writing the translation of that extract from dictation.
- ³² Codex Atlanticus, fol. 218v-b.
- ³³ De ludo geometrico.
- ³⁴ Codex Atlanticus, fol. 139r-a.
- ³⁵ Codex Madrid I, fol. 87v.
- ³⁶ Treatise on Painting, chap. 31.
- 37 Ibid., chap. 10.
- 38 Ibid., chap. 9.
- 39 Ibid., chap. 19.
- 40 Ibid., chap. 7.
- 41 Ibid., chap. 1.
- 42 Manuscript G, fol. 96v.
- 43 Treatise on Painting, chap. 33.
- 44 Codex Atlanticus, fol. 11r-b.

- fol. 1r. This is valid for the descriptive disciplines such as anatomy, machines, and the like.
 The folios on anatomy at Windsor and in Codex Madrid I can be considered a collection of illustrations accompanied by captions like the pages of an atlas.
 ⁴⁶ Codex Atlanticus, fol. 108v-b.
 ⁴⁷ Added at the top of Codex Madrid I, fol. 6r.
 ⁴⁸ Codex Atlanticus, fol. 119v-a.
 - ⁴⁹ Quaderni d'Anatomia, fol. II, fol. 14r.

⁴⁵ Quaderni d'Anatomia, vol. II,

NOTE: Phaidon Press Limited, London, has kindly given permission to reprint the various excerpts of translations from Jean Paul Richter, *The Literary Works of Leonardo da Vinci*, 2d ed. (London, 1939).

LIST OF **ILLUSTRATIONS**

- Abbreviations: a above b below
- c center
- l left
- r right

INTRODUCTION

- 2 Signature of Leonardo from the contract for the Virgin of the Rocks, April 25, 1483
- 2 Portrait of Leonardo's left hand, Atlanticus 283v-b
- 6 Codex Madrid II, folio 65 recto
- Codex Madrid I, folio 152 recto
- 9 Atlanticus 168r-a

THE MECHANICS OF WATER AND STONE

- 11 Windsor 12660r 12-13 Photo Leonard von Matt 16-17 Windsor 12660v 18 Atlanticus 46r-b 18-19 Map of Tuscany 19 Madrid I 111r 211 Windsor 12690 20 Madrid I 114v 21r Madrid I 150r 23 Windsor 12682 23 Windsor 12278r 23 Windsor 12277 24 l Madrid I 124v 24r Madrid I 115r 25a Madrid I 125r 25r Madrid I 33r 25 l Madrid I 150r 26 Madrid I 134v 271 Madrid I 22v 27r Madrid I 151v 30 Ms.F 53r 31 Atlanticus 395r-a 32c Engraving, Schweizerisches Landesmuseum, Zürich 32r Painting by Sustermans, Florence. Uffizi,
- Mansell 321 Mansell
- 341 Forster 12 42v
- 34r Forster 12 43v
- 351 Forster 12 48r

35r Forster 12 52v 36 Atlanticus 81r-a 371 Ms. F.90v 37c Ms. F.90r 37r Ms. F. 47v 381 Mansell 38r Madrid II 126r 39 Photo Liselotte Meyerlist 41 Arundel 241r 42 Atlanticus 275r-a 43 Atlanticus 335r-a 44 Atlanticus 335r-a 44 Atlanticus 141v-b 45 Atlanticus 141v-b 47 Artwork Franz Coray 48-49 Windsor 12399 501 Bust by Buggiano, Cathedral, Mansell 50r Sketch by Raphael, Louvre, Paris, Service de Documentation de la Réunion des Musées Nationaux 51 Scala 54, 56 Madrid I 142v 55, 57 Madrid I 143r 58 Forster II 92r 591 Ms. A 56v 59c Arundel 158r 59r Arundel 158v 601 Ms. 50r 60c Ms. A 53r 60r Madrid I 139r 62 Madrid I 84v 63 Engraving from MM. Bousquet dated 1743, Schweizerisches Landesmuseum, Zürich 64 Photo Anderson, American Heritage Photographic Service 65 Atlanticus 310v-b 66-67 Atlanticus 310r-b LEONARDO'S WRITINGS 69 Madrid I 21r 70 Madrid II 2v and 3r

- 71 Madrid II 3v
- 73 Portrait (Junger Edelmann) by Giovanni Antonio Boltraffio, Kunstmuseum Bern, possession of the Gottfried Keller Stiftung
- 73 Portrait engraved by C. Pye, London, Mansell
- 74-75 Madrid I passim
- 76-77 Examples of small letters from various manuscripts

78-79 Title pages of Codex Madrid I and II 80-81 List of notebooks used by Melzi for the Treatise on Painting, Urbinas 230v and 231r 80 Original last page of Madrid II, 140v 80 Original last page of Madrid I, 191v 84 Atlanticus 168r-a 85 Madrid I 5r 86 Madrid II 35r 86 Madrid II 83v 87 Madrid II 24r 88 Summa de arithmetica by Luca Pacioli, Ambrosiana, Milan 89 Madrid II 78r 91 Madrid II 48v 92 Variations on the letter E. 93 Madrid I 159v 93 Madrid II 151r 93 Madrid I 46r 93 Madrid I 161v 93 Madrid I 78r 93 Madrid I 79v 95 Portrait by Saco Bar, Museum of Capodimonte, Naples, Scala 96 Atlanticus 184v-ab 97 Atlanticus 58r-a 98-99 De divina proportione by Pacioli, Ambrosiana, Milan 100 Atlanticus 111v-a 101 Atlanticus 106r-b 102 Madrid I 1v 102 Madrid I 1v 103 Madrid I 1v 104 Atlanticus 221v-b 105 Atlanticus 110v-a 106 Atlanticus 167r-ab 110 Portrait by Daniel Berger, Mansell 110 Fitzwilliam Museum, Cambridge, England, Mansell 111 Portrait by W. Hilton from the original by Rubens, Mansell 111 Godolphin Collection, Mansell 114 Codex Ashburnham 361 25a 117 Madrid II 112r 117 Codex Madrid II 112r 119-120 Windsor 12692 120a and b Windsor 12694 121, 123b/r Windsor 12692v

- 122 Windsor 12692v
- 123a/r Windsor 12692v
- 123r/c Windsor 12699

THE WORDS OF LEONARDO

- 125 Atlanticus 397r-b
- 127 Windsor 12697
- 128 Windsor 19149v
- 129 Windsor 19150v

APPENDIX: THE BICYCLE

- 155 Atlanticus 133v
- 156 Atlanticus 132r
- 156-157 Artwork Franz Coray
- 157 Atlanticus 133r
- 158c Atlanticus 132v and 133v
- 158b Atlanticus 133v
- 160 l/c The first velocipede, after Freiherr von Drais, 1818, Swiss Transport Museum, Lucerne
- 160a/r John Hobby's monocycle, ca. 1870,
- Deutsches Museum, Munich 160b/l Bicycle of Philip Morith Fischer, 1870, Swiss Transport
- Museum, Lucerne 160b/r Michaux' "boneshaker." 1870, Swiss Transport
- Museum, Lucerne
- 161a/l "Atlantic Special" ordinary, 1882, Deutsches Museum, Munich
- 161a/r Ordinary, ca. 1900, Swiss Transport Museum, Lucerne
- 161b/l Ordinary "Star" from USA, ca. 1900, Swiss Transport Museum, Lucerne
- 161b/r Modern bicycle, ca. 1900, Swiss Transport Museum, Lucerne
- 162 Atlanticus 133v
- 163 Atlanticus 133v
- 164 Drawing by Antonio Calegari, after the bicycle on Atlanticus 133v
- 165b Madrid I 10r

LEONARDO'S LIFE: A CHRONOLOGY

- 166-167 Fresco by Raphael (1483-1520), Vatican Stanza della Segnatura 169 Windsor 12579r
- 1469 Portrait by Lorenzo di
- Credi, Uffizi, Florence, Scala
- 1470 Bust by Verrocchio, D.C.,

Samuel H. Kress Collection

- 1472 Inscription of Leonardo's name in The Guild of St. Luke, the register of Florentine painters, State Archive, Florence, Scala
- 1473 Uffizi, Florence, Mansell
- 1475 Uffizi, Florence, Scala
- 1477 Louvre, Paris
- 1479 Woodcut from the Supplementum chronicarum, Florence, 1490 Drawing, Musée Bonnat, Bayonne
- 1480 Uffizi, Florence, Scala 1482 Ms. Italien 372,
- Bibliothèque Nationale, Paris 1483 Louvre, Paris, Scala
- 1484 Windsor 12358r
- 1485 Czartoryski Gallery, Cracow
- 1487 Windsor 12495r
- 1488 Ms. 2037 5v, Institut de France
- 1489 Windsor 19057r
- 1490 Codex Ashburnham 361
- 25a Portrait of a Musician.
- Ambrosiana, Milan
- 1491 Portrait, Ambrosiana, Milan
 - Horse mold, Madrid II 157r
- 1493 Madrid II 151v
- 1494 Forster II2 92r
- 1495 Sala delle Asse, Sforza Castle, Milan, Photo Sinigaglia
- 1496 Museum of Capodimonte, Naples, Scala The Last Supper, S. Maria delle
- Grazie, Milan, Scala 1498 National Galery, London
- 1500 Louvre, Paris
- 1502 Map, Windsor 12284 Portrait, Rome, Scala
- 1503 Windsor 12326r
- 1504 Louvre, Paris
- 1505 Codex on the Flight of Birds 8r
 - 1506 Windsor 12518
- 1507 Windsor 12399
- 1509 Louvre, Paris, Scala
- 1510 Portrait engraved from
 - Theatrum vivorum by
 - P. Freher, Nuremberg
 - By courtesy of The Wellcome Trustees.
- Anatomical sketch, Windsor 19016r

- 1511 Portrait by Andrea del Gobbo, called Solario, Louvre Paris
- 1512 Biblioteca Reale, Turin
- 1514 Windsor 12380
- 1516 Portrait (Junger Edelmann) by Giovanni Antonio Boltraffio, Kunstmuseum, Bern, possession of the Gottfried Keller Stiftung
- Masquerade, Windsor 12574 1517 Castle of Amboise, not by
- Leonardo, Windsor 12727 1518 Windsor 12670v
- Photo Karquel

INDEX

Abbiate Grasso, 19 Adda River, 20, 40-46, 42-45 landscape drawing, 180 Adoration of the Magi, 173 Alberti, Leon Battista, 101, 113 Alphabet, 74-77, 92-93 Alps, foothills, canals for irrigation, 14-15 Amboise, St. Florentin Church, 183 Anatomy, 125, 148-151 skulls, 175 Angel by Leonardo, in Verrocchio's Baptism of Christ, 172 Annunciation (Louvre), 172 Aqueducts, 12-13, 14 Arch, construction, 50, 52-53, 54-67, 58-65 Archimedean screw, 46 Archimedes, 11, 95, 117 Archinti, Count Orazio, 82 Architecture, 50-66, 54-67, 177 structural experiments, 53-65, 54-67 Arconati, Count Galeazzo, 82 - 83Arconati, Luigi, 82 Arezzo, map, 23 Arno canal, (Arno River diversion), 15–24, 18–19, 22–23, 87, 89 Arno River, maps, 18-19, 22-23 Arundel, Lord, 83, 111 Ashburnham, Lord, 83, 111, 114 Baroncelli, Bernardo Bandini, drawing, 173 Battle of Anghiari, 90, 179 Bellows, hydraulic experiment, 20 Beno de'Gozzadini, 19 Benois Madonna, 173 Bernoulli, Daniel, 32, 32 Bernoulli, Johann, 61, 63 Bicycle, 155-165, 155-165 Birds, flight of (see Flight of

- birds) Boltraffio, Gian Antonio, 160 Bonati, 37
- Borgia, Cesare, Leonardo in service of, 36 Borromeo, Federigo, Cardinal, 73, 74, 82
- Botticelli, Sandro
- Bramante, Donato, 53 in Milan, 50

sketch by Raphael, 50 Branconi, G.B., Leonardo's two lost paintings for, 181 Brianza lakes, 40, 42 Brivio, 45 Brizio, Anna Maria, 8 Brunelleschi, Filippo, 50, 101 Santa Maria del Fiore, Florence, 50, 50

Cabeo, Father, 37 Caccia, Gaetano, 82 Calegari, Antonio, 165 Campano, (Campanus), Johannes, translation of Euclid, 12-14, 18, 19, 22, 23, 29-30, 40, 41;94 Canals, Arno (see Arno canal) for irrigation, 14, 31, 33 Naviglio Grande, 19 (See also Milan, hydraulic engineering project) Castelli, Benedetto, 201 Cavallo, Il (bronce horse for equestrian statue), 116 casting, 176 model, 176 sketches, 174, 176 Certosa, 34 Cher River, 35, 46 Chiana valley, artificial lake planned, 15, 23 Cichognole, (spiral tubes for water power), 34, 46-47 Circle, squaring, 90, 95-96, 97, 100-101, 104, 117 Clouds, 143 Codex Arundel, 69, 83, 111 architectural construction, 58 hydraulics, 41 Codex Ashburnham, (two codices), 70, 83, 111 church, dome, 175 Codex Atlanticus, 69, 73, 78, 79, 82 Arno River project, 15, 18 bicycle, 155, 163, 165 Euclid's Elements, 94, 97 hydraulics, 20, 29, 30, 31, 33, 34, 36 Leonardo's left hand, 74-75 Leoni's compilation, 74-79, 164, 80, 155 Milan Cathedral, 64 squaring the circle, 90, 95-97,

100-101, 104, 117 word list, 102 Codex on the Flight of Birds (see Flight of Birds) Codex Forster (three codices) 69, 82,110 Codex Forster I: geometry, 90, 96 hydraulics, 34, 47 Codex Forster II: architectural construction, 58, 177 Codex Leicester, 69, 83 110 hydraulics, 29, 34, 47 Codex Madrid I, 56-57, 70, 79, 114, 116 architectural construction, 54-57, 58-60 Arno River project, 18 bicycle, 155-165, 165 handwriting, 74-75, 76-77, 85 hydraulics, 20, 20, 21, 24, 24, 26, 27, 28, 29, 30, 31 Leoni's editing, 76, 82 word list, 102 Codex Madrid II, 70, 78, 87, 89, 116 Arno River project, 87 Battle of Anghiari, 90, 176 casting, 176 flight of birds, 86 list of manuscripts and books, 71, 72, 90 mathematics, 89, 90, 91, 94-97 Piombino project, 89, 90 proportions, family tree of, 88 waves, 38, 87, 89 Codex Trivulzianus, 69, 82, 91-92, 102 Codex Urbinas, 72 Treatise on Painting sources, 80-81 Coltano, 15 Commandino, 28 Corbeau, André, 79

De ponderibus, 110–111 Dora River, 20

Equiparation, science of, 90, 96 Este, Beatrice d' (wife of Lodovico Sforza), portrait, 176 Este, Isabella d' (wife of Giovanni Gonzaga), 178 portrait, cartoon for, 178 Etruscans, hydraulic works, 13 Euclid, 97, 97 Elements, copied by Leonardo, 90, 94, 96, 97 Eupalinos, aqueduct, 14

Ficino, Marsilio, 109, 121 Figgini, A., 74 Flight of Birds, 86, 126, 179 Codex on, 82, 141 Florence, 50 Arno project, (see Arno canal) Palazzo Vecchio, frescoes (see Battle of Anghiari) Santa Maria del Fiore (Cathedral), 50, 51 Fluids, (see Hydraulics) Forster, John, 82, 110 Fountains, 21 France: flood control in, 35 Leonardo in, 40, 47 Francesco di Giorgio Martini, 90, 113 influence on Leonardo, 115 manuscript with sketch by Leonardo, 115 Treatise on Architecture, Engineering, and Military Art. 114 Friuli, 34, 35 Fucecchio marshes, 15

Galilei, Galileo, 32, 63 law of falling bodies, 33 Gallerani, Cecilia, portrait (Lady with an Ermine), 174 Gavardi, Lelio, 73 Genoa, 36 Geometry, 72, 75, 90, 92, 94-95, 96 (See also Squaring the circle) Ghiberti, Lorenzo, 113 Gioconda (see Mona Liza) Giorgi, 28 Gonzaga, Giovanni Francesco II, Duke of Mantua, wife (see Este, Isabella d') Gorizia, 34 Gotthard pass, 20 Gozzadini, Bene de', 19 Greek science, 12

Hamilton-Jacoby equations, 63 Hamilton's principle, 63 Heron of Alexandria, 11, 26, 28 - 29.46fountains, 21 Hooke's law, 63 Horse, bronze (see Cavallo, II) Horses: in Battle of Anghiari, 179 notebook on, lost, 71 Huygens, Christian, 38 Huygens' principle, 36, 38 Hydraulics, 11, 13, 11-15, 16, 20, 20, 21, 34, 36, 37, 38, 40, 42 ancient knowledge of, 13 Milan project, 14, 16, 35, 40, 41 theoretical studies, 21 - 27, 24-28, 29, 30, 31 (See also Arno canal)

Imola, map, *179* Irrigation, canals, 15, 30, 31 Isonzo valley, flood control, 34 Irvea Canal, 20

Lady with an Ermine, 174 Lake Como, 40, 42-45 Lake of Lecco, 42, 47 Lake of Trasimeno, Arno River project, 15 Lambro River, 42 Landscapes: Adda River, 180 Arno valley, Leonardo's first dated drawing (1473), 172 Last Supper, 50, 177 Latin, Leonardo's study of, 91-92, 100, 102-103 Leda and the Swan, 180 Leibnitz, Gottfried Wilhelm von, 32 Leicester, Thomas Coke, Lord, 83.110 Leo X, Pope, 41 Leonardo da Vinci, 69, 74-75, 76-77 handwriting, 69, 92-93 left hand, drawing, 74-75 life and works, chronology, illustrated, 169-183 Self-portrait (Biblioteca Reale, Turin), 181 Self-portrait (Windsor Collection), 169 signature, 2, 69 Testament (will), 183 WRITINGS, 68-123 classification of manuscripts,

68-123, 81, 82-87 decision to become a writer, 91 - 97on equiparation, planned, 96 library, lists of manuscripts and books, 71, 81, 90 literary style, 113-115, 114 lost manuscripts, 69-77 manuscript collection and codices, 69-87, 110-111 manuscripts preserved and copied, 72-82 words, collection of, 91-92, 102-103 (See also Treatise on the Motion and the Measure of Water WRITINGS, PASSAGES FROM, 125-153 Leoni, Pompeo, 87 and Codex Atlanticus, 69, 164 Leonardo's manuscripts collected and arranged, 74-82,80-81 Libri, Count Guglielmo, 83, 111 Lodi, 20 Lodovico il Moro (see Sforza, Lodovico) Loire River, 35 Lombardy. canals, 15, 30 hydraulic works, 33 London: British Museum, 69, 83 Victoria and Albert Museum, 69, 82, 110 Lucomagno pass, 20 Lytton, Lord, 82, 110 Madonna with the Yarnwinder, 178 Madrid, Biblioteca Nacional, 70, 78.82 Madrid Codices, (see Codex Madrid I; Codex Madrid II) Manetti, Antonio, 101 Manuscript A, architecture, 58-60 Manuscript B, 70, 83, 91, 111 hydraulics, 35-36 Manuscript C, 70, 74, 82 hydraulics, 35-36 Manuscript D, 70, 82 Manuscript F, hydraulics, 37

Manuscript K, 70, 82, 94, 99

Manuscript I, 70, 94

Manuscript M, 70, 94 Maps, 22-23 Arno River, 18-19, 22-23 Marco, d'Aggiono, 160 Marinoni, Augusto, 7 Martesana Canal, 40, 42 Martini, Francesco di Giorgio, (see Francesco di Giorgio Martini) Martino della Torre, 19 Mathematics, 90, 88-107, 94-97, 112, 117 Matthias Corvinus, King of Hungary, 109 Mazenta, Alessandro, 74 Mazenta, Giovanni Ambrogio, 74 Mazenta, Guido, 74 Mechanics, of structural design, 52-65, 54-60, 65-67 Medici, Giuliano de', 41 Melegnano, Battle of, 40 Melzi, Francesco, 72, 83 Leonardo's manuscripts arranged and copied, 72-77 Treatise on Painting compiled by, 72-77, 80-81, 108-109 Melzi, Orazio, 74 Michelangelo, David, 179 Milan, Biblioteca Ambrosiana, 69, 73, 82-83 (see also Codex Atlanticus) Biblioteca Trivulziana, 69 (see also Codex Trivulzianus) Bramante in, 50 canal (Naviglio Grande), 15, 19 Cathedral, 64-67 hydraulic engineering project, 13-15, 33-36, 37, 41-49 Leonardo in, 35-37, 50, 123 San Francesco il Grande, altarpiece (see Virgin of the Rocks, Louvre) Santa Maria della Grazie, 50, 58-60 (see also Last Supper) Sforza Castle (see Sforza Castle) Mona Lisa (Gioconda), 179 Mugnano, 15 Music, compared with painting, 108

Naviglio Grande, 15, 19–20 Newton, Sir Isaac, third law of motion, 46 Novara, 20

Pacioli, Luca, 72, 89, 90, 91, 94, 95, 97, 99, 100, 101, 177 Da divina proportione, 89, 95, 99 Leonardo's illustrations, 89, 91, 98-99, 177, 178 Summa de arithmetica, 89, 90, 91 Paderno, 40 Painting, music compared with, 109 poetry and, 108-113 Paris, manuscripts (see also under Manuscript), 70, 73, 83 Pavese Canal, 34 Perspective, 101, 133 Philip II, King of Spain, 74, 78, 82 Pictographs, 121, 119-121 Piedmont, 14 Piero da Vinci (father of Leonardo), 170, 179 Piero della Francesca, 113 Piombino fortifications, 89, 90, 157 Leonardo in, 90, 36, 38 Pisa: and Arno River project, 15, 18-19, 22-23 Pistoia, Arno River project, 15, 19 Po valley, hydraulic works, 11-15, 20, 29, 37 Poetry, Leonardo's ideas on, 108-113 Pontine Marshes, draining, 41 Portrait of a Musician, 176 Prato, Arno River project, 15, 19 Proportions, family tree of, 89 (See also Pacioli, Luca, De divina proportione)

Raphael, 166–167 Bramante, sketch, 50 Rebuses, pictographs, 119–121 Reciprocating motion (see Motion) Riddles, 119–121 Rocchetta a Santa Maria, 40, 48–49 Romagna, 36 Rome: Leonardo in, 47 Pontine Marshes, draining, 41 Sistine Chapel (see Sistine Chapel) Rome, ancient: aqueducts: 12–13, 14 building technique, 52 Romorantin marshes, 35, 41 Rotary motion, (*see* Motion)

Sailing ships, 86 St. Anne (see Virgin and Child with St. Anne) St. Jerome, 173 St. John the Baptist, 181 Sala delle Asse (see Sforza Castle) Salai, Leonardo's pupil, 156, 158, 159-165, 162 San Bernardino pass, 20 San Savino, 15 Screws Archimedean, 46 Serravalle, tunnel for Arno River project, 15, 18-19, 22-23 Sesia River, 20 Sesto marshes, 15, 19 Sforza, Lodovico (Il Moro), Duke of Milan, 94, 109 Leonardo with, 119 wife (see Este, Beatrice d') Sforza Castle, Milan, Sala delle Asse, decorations, 177 Ships, sailing, 86 Siena, Cathedral, 50 Sixtus V, Pope, 13 Spanish Ministry of Education, 7 Spluga pass, 40 Spring, behavior under stress, 62,63 Squaring the circle, 90, 94-96, 100-101, 104-107, 117 Stress on bar or spring, 62, 63 Taurus Ediciones, 7 Tiber River, in Arno River project, 15, 23 Ticino River, 19, 20 Torricelli, Evangelista, 32, 33 Toscanelli, Paolo dal Pozzo, 101 Tre Corni, 40, 45, 47 landscape drawing, 48-49 Treatise on Painting, 108,

111-113

180

manuscript, 72-76, 81

Trivulzio, Gian Giacomo,

Turin, Biblioteca Reale, 69

Trivulzio, Prince, 82

Treatise on the Motion and the

equestrian statue, planned,

Measure of Water, 82

Turks, 34 Tuscany, water power, 14 Young man on horseback in masquerade costume, 182

Ugnano, Battle of, 15

Zammattio, Carlo, 7

Valla, Giorgio, 95 Valéry, Paul, 6 Venice, Colleoni statue, (see Verrocchio) Galleria dell'Academia, 69 Leonardo in, 36 Verrocchio, Andrea Baptism of Christ, head of an angel, 172 Vinci, Leonardo's childhood home, 170 Virgin and Child with St. Anne, 180 (Louvre) Virgin and Child with St. Anne, (cartoon, National Gallery, London), 178 Virgin of the Rocks (Louvre), 174 Viviani, Vincenzo, 63 Water, 82, 87, 114, 115 measurement (ounces), 31, 33, 40, 41 speed measurement, 37 Water power, 14-15, 33 cichognole, 46 measurement, 40, 41 Waterfalls, 27, 46 Wave motion, 36, 37-38, 87, 89, 114, 115 Wheels, geared, 85, 102, 165 Windsor Collection, 69, 82, 111 Adda River, landscape, 180 anatomical drawings, 175 The Deluge, 182 deluge, description of, 115 head of a woman, (ca. 1518), 183 heads, grotesque, 175 horses, for equestrian statue, 174 hydraulic engineering, 13-15, 16-17, 48-49 Imola map, 179 Leoni's compilation, 78-79 pictographs, 119-121 young man on horseback in masquerade costume, 182 Words, collection of, 92-93, 102-103